LAWREN HARRIS

AN INTRODUCTION TO HIS LIFE AND ART

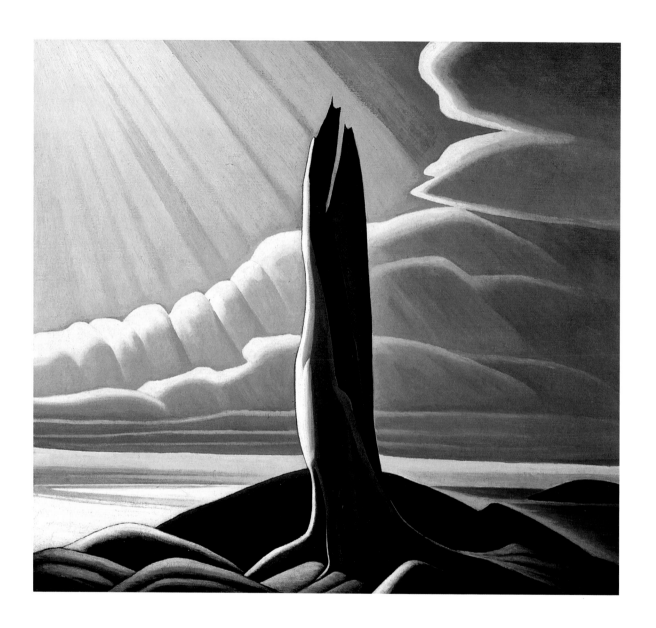

North Shore, Lake Superior 1926

Oil on canvas; 102.2 x 128.3 cm

Lawren Harris

AN INTRODUCTION TO HIS LIFE AND ART

JOAN MURRAY

FIREFLY BOOKS

A Firefly Book

Published by Firefly Books Ltd. 2003

First Printing

National Library of Canada Cataloguing in Publication Data

Murray, Joan
Lawren Harris : an introduction to his life and art /
Joan Murray.
Includes bibliographical references and index.
ISBN 1-55297-764-1 (bound).—ISBN 1-55297-763-3 (pbk.)
1. Harris, Lawren, 1885-1970. 2. Painters--Canada--
Biography.
I. Title.
ND249.H36M87 2003 759.11 C2003-901608-0

Publisher Cataloging-in-Publication Data (U.S.)
(Library of Congress Standards)
Murray, Joan, 1943-
Lawren Harris : an introduction to his life and art /
Joan Murray.—1st ed.
[] p. : ill. (chiefly col.) ; cm.
Includes index.
Summary: A brief history of the life and work of the Canadian
artist and founding member of the Group of Seven.
ISBN 1-55297-764-1
ISBN 1-55297-763-3 (pbk.)
1. Harris, Lawren, 1885-1970. 2. Painters—Canada—Biography.
I. Title.
759.11/ 092 21 ND249.H28M87 2003

Published in Canada in 2003 by
Firefly Books Ltd.
3680 Victoria Park Avenue
Toronto, Ontario, M2H 3K1

Published in the United States in 2003 by
Firefly Books (U.S.) Inc.
P.O. Box 1338, Ellicott Station
Buffalo, New York 14205

FRONT COVER:
Red House, Winter, c. 1925

BACK COVER:
Isolation Peak, c. 1930

TITLE PAGE:
North Shore, Lake Superior, 1926

Design: Counterpunch/Linda Gustafson
Layout: Tinge Design Studio

Printed and bound in Canada by Friesens,
Altona, Manitoba

*The Publisher acknowledges the financial support of the Government of Canada through the
Book Publishing Industry Development Program for its publishing activities.*

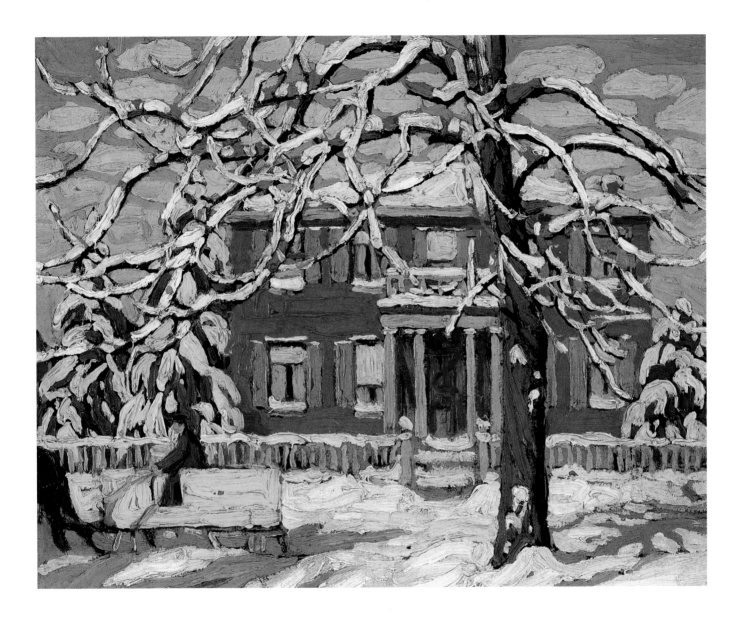

Red House and Yellow Sleigh 1919

Oil on board; 26.7 x 33.7 cm

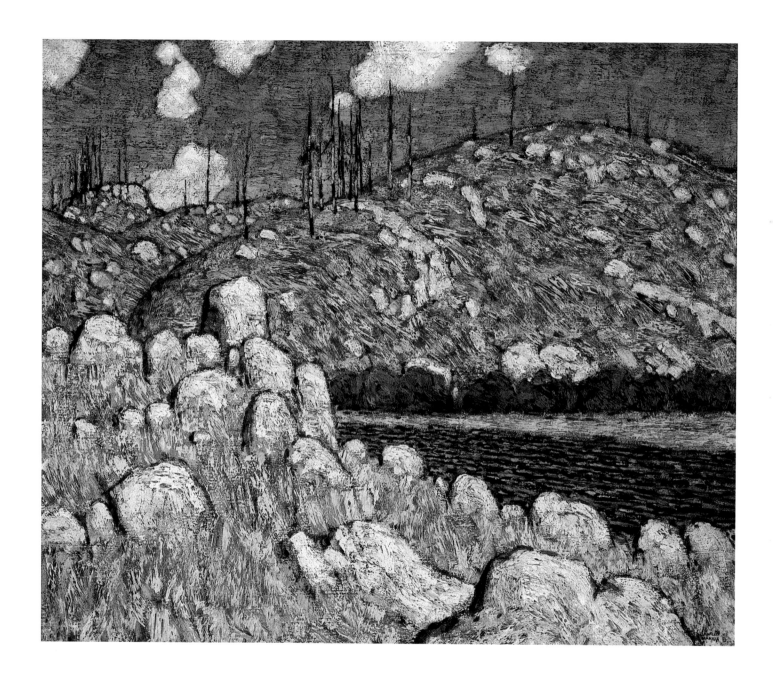

Laurentian Landscape 1913–1914

Oil on canvas; 76.2 x 88.3 cm

Contents

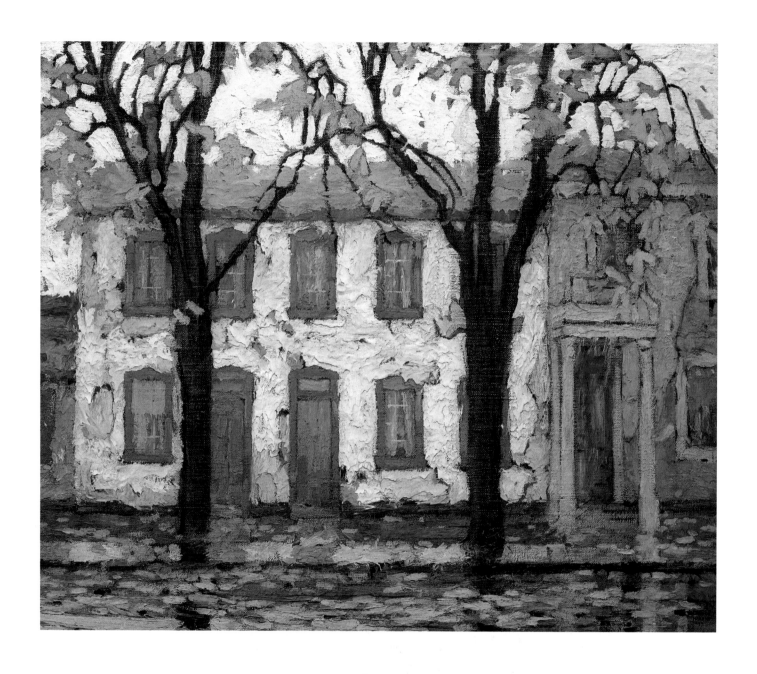

Houses, Chestnut Street 1919

Oil on canvas; 81.7 x 97.2 cm

Introduction

Lawren Harris was a leader in the creation of the Group of Seven, a founding member and the first president of the Canadian Group of Painters, a founder of the Federation of Canadian Artists, and a founder of the Transcendental Painting Group in the United States — in all, a unique record for a Canadian artist. His landscapes not only showed the extravagant buoyancy of the continent, but also depicted other-worldly interests. Afterward he turned to abstract art, and his later works showed the influence of abstract expressionism.

Lawren Harris never hesitated to reinvent himself. At the age of 49, he abandoned social convention and artistic orthodoxy. He gave up his place in Toronto society and in the Toronto art community in favour of a new existence. In 1934, already a much-admired painter, he began to change his circumstances. He divorced, married the charismatic Bess, and with her set off to new places: first to Hanover in New Hampshire, then to Santa Fe in New Mexico, and then to Vancouver.

As he grew up, Lawren Harris often heard the phrase "self made" — used to describe someone who starts with little and grows rich. Although born to wealth, he was self-made, but in his own, highly original way.

I would like to thank Peter Larisey, the biographer of Harris, who kindly read the manuscript and offered suggestions.

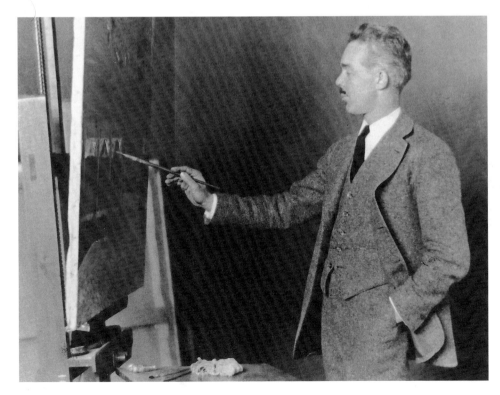

Lawren Harris painting in the Studio Building c. 1920

One: The Beginnings

ONTARIO: CHILDHOOD AND GROWING UP

Lawren Stewart Harris was born on October 23, 1885, the son of Tom and Anna Harris and the first of two children – his brother, Howard, arrived fourteen months later – in the little Ontario town of Brantford. It was his grandfather, Alanson, who laid down the Brantford roots, beginning the family enterprises with his father, Lawren's great-grandfather John, by buying and operating a sawmill in Whiteman's Creek in Upper Canada, as Ontario was then known. From there Alanson moved on to buy a foundry at nearby Greensville, where he began

Lawren Harris

to manufacture farm implements. In 1872 he made the move to Brantford, about a hundred kilometres southwest of Toronto, because he needed a larger factory for his expanding business.

There the Harrises made their fortune with the invention of the Brantford Light Binder, a harvesting machine that cut grain and bound it into bundles. That device competed with the Toronto Light Binder, manufactured in Toronto by Hart A. Massey. In 1891, to allow the Massey firm to exploit the superior Harris invention, Massey merged with A. Harris, Sons & Company, forming the legendary Massey-Harris Company, later to be known as Massey-Ferguson. Lawren Harris's share of the fortune meant that he would be free from financial worries for the rest of his life.

The family was strict, with a confining Presbyterian and Baptist obsession with individual sin and damnation. Lawren's grandfathers and two of his uncles were ministers. Prayers were said mornings and evenings at home, and Lawren attended church three times on Sunday. On that day the only reading permitted was the Bible. There was no work, but neither was there play. Still, the two brothers, always close, were known for their escapades. On one occasion they dressed in their parents' clothes when left at home for misbehaviour, then headed straight to church – convulsing the congregation.

Lawren was famous for his pranks. He plagued the poetess Pauline Johnson, who lived in a house behind his home. And once, when he should have been studying, he cut out little paper figures of teachers and friends, stuck on some pine gum, and shot the cutouts to

the ceiling, where they remained. Such activities may have been born of the desire to compensate for the weak health that had pursued him from birth. According to family tradition, he had appeared still born. The attending doctor tried without success to bring him to life, then simply put him aside to look after the mother. A relative, "Little Auntie," ready for an emergency, worked over the baby until he began to breathe and cry. The few minutes' delay was thought to be responsible for medical problems that Lawren experienced throughout his childhood and for the heart condition that affected him during his life.

While growing up, he spent considerable time in bed or confined to the house. It was difficult to occupy the high-spirited boy. Part of the time he was tutored; to keep him busy the rest of the day, his parents introduced him to drawing and painting. Lawren began to draw what he could see from his room and in his room. He illustrated stories that were read to him and drew pictures of family and friends. He even wrote his own stories, which he illustrated from imagination.

Anna and Tom Harris were creative parents. They made the two boys responsible for their actions by permitting them to do just about anything – then let them take the consequences. This approach required patience, but ultimately gave the children the ability to think ahead and apply self-discipline. From such inventive and caring forbears, they acquired independence and a personal code of moral behaviour.

Lawren was fortunate in his mother, to whom he was always a close and happy companion. A few months before his ninth birthday, his father died of Brights disease, an ailment of the kidneys, and Anna took over the running of the family. Loving and generous, courageous and blessed with a sense of humour, she was a devoted mother. She worked to fill the gap created by her husband's death, revealing the strong will beneath her buoyant personality. With her father, she took the boys to Europe. In 1910, after being briefly married (Edward V. Raynolds, her husband, died on their honeymoon), Anna turned to Christian Science. For the rest of her life this faith, with its traditions of optimism and energy, sustained her. Being a woman of many talents, she was always busy. She sang and played the piano and organ in her church, First Church of Christ Scientist. A reader (meaning a lay preacher), she was for a time in charge of the Sunday School. She painted china, which she usually gave to friends and relatives on birthdays. Her greatest pleasure was to give, which she did for the rest of her life. During the First World War, for instance, she worked in England, helping to run the privately funded Massey-Harris Convalescent Hospital. Lawren found in her a source of sympathy. Much later, during the crisis of his divorce, he came to her for counsel. Anna moved often to live near her son in his various homes, even outside of Canada. She was not only a good mother, but also a perpetual enthusiast. This quality, as well as her passion for music, was to characterize her son in his later life.

In 1894, when Tom Harris died, Anna moved her small family to Toronto, to be near her parents. She would have thought of her father as a stand-in for the boys' dad. She might also have thought about the more extensive opportunities for schooling offered by Toronto. For the time, however, she entered the boys in a local public school on Huron Street.

By contrast with Brantford, Toronto was a large, exciting city. Its population in 1901 was more than 200,000. The Board of Trade, in a pamphlet of 1903, praised the city's trees, parks, climate and art: "Toronto is widely known as the artistic, literary, and musical centre of the Dominion." The pamphlet noted several

museums and organizations, including the Ontario Society of Artists (established in 1872), the Central Ontario School of Art, the Women's Art Association, and the Toronto Art League.

After several years in the city, Anna boarded the boys at the recently opened St. Andrews College in the affluent Rosedale neighbourhood. Lawren was not much of a student there, except in subjects that captured his imagination, such as history and literature. But he delighted in sports – especially track and tennis – and became a strong swimmer and diver.

Family tradition has it that Lawren drew for the school paper at St. Andrews; he certainly wrote a story for it, basing his hero, Jack Brown, on the Harris relative who invented the Brantford Light Binder. Lawren turned Brown into a romantic figure, writing, "Jack Brown continued his inventions, not to better his father's farm, but to better the world." Such idealism would spark his thinking for the rest of his life. He, too, would want to better the world.

After graduating from Grade 10 in 1903, Lawren registered in University College at the University of Toronto, where he remained as a student for perhaps half a year. He spent that time filling a notebook with pencil sketches of teachers and fellow students. A professor, A.T. DeLury, seeing his work, called at the family residence and told Anna that Lawren should study art. For this, the best place was Europe, DeLury believed. Anna was supportive as always. Her one stipulation was that her son should go to Berlin, where her brother, William Kilbourne Stewart, a professor of German at Dartmouth College in New Hampshire, was to be a postgraduate student in German literature. In the autumn of 1904, Lawren sailed for Germany.

BERLIN

Berlin was a large, cosmopolitan city, fast becoming the cultural and commercial capital of Germany. Between 1870 and 1914, the population rose from 826,000 to more than two million people to make it the largest industrial centre in Germany. It offered a rich and varied cultural feast with a famous museum island, first opened in 1830, upon which stood a number of important museums designed to serve a new, culturally aware middle class. In such a world capital Lawren Harris thoroughly enjoyed himself, particularly because he had the opportunity to both hear and study music. He attended the opera and concerts, took violin lessons, and befriended music students from North America. He also made the rounds of the public and private galleries, where he could see masterpieces of European and particularly German art.

In 1906, the National Gallery in Berlin organized an important show of German art from 1775 to 1875. Harris would surely have attended this exhibition, with its more than two thousand works and the section devoted to the "Recent Masters." He possibly already knew the work of one of these artists, Caspar David Friedrich, a chief exponent of the German Romantic movement and one of the most original geniuses in the history of painting, whose landscapes convey a sense of haunting spirituality.

At the same time, Harris, influenced by his uncle, immersed himself in American transcendental authors such as Ralph Waldo Emerson and William James. In his essays, Emerson sought to recover man's original connection to the universe, a view enjoyed by earlier generations who beheld God and nature face to face.

Harris's art training in Berlin was strict. He attended studio classes with three teachers: Franz Skarbina, Fritz von Wille, and Adolf Schlabitz. For the first two years, mornings and evenings, he worked with other students in the studio, drawing in graphite and charcoal and using watercolour to paint the model. Afternoons he spent out of doors painting small watercolours of houses and buildings in older parts of the city, including the slums. His teachers let him work in oils during his last two years in Berlin, only after he had mastered the basics. He painted mostly portraits and figures during this time.

Although his training was conventional and his teachers conservative, Harris would have become aware of the avant-garde movement in Berlin, by then called the Berlin secession, whose artists regularly exhibited their own realist and regionalist works, many of which were influenced by postimpressionism.

The term postimpressionism, coined in 1906 by the British art critic and painter Roger Fry, is most commonly associated with the 1910 show Fry organized at London's Grafton Galleries. Called "Manet and the Post-Impressionists," the exhibition included works by Paul Cézanne, Vincent van Gogh, Paul Gauguin, Georges Seurat, and Henri Matisse. Harris would have been able to see the work of the first three of these artists in Berlin, but his training was so academic and structured that he might not have understood their aims.

Perhaps he discussed impressionism with his teacher and friend, Schlabitz, who had studied in Paris. They shared two summer trips. In the summer of 1906 the two went on a walking and sketching tour of the Austrian Tyrol and even did some mountain climbing, in the area near Brixlegg; in 1907 Harris stayed with Schlabitz in his house near the medieval town of Dinkelsbühl, in southern Germany. On the second trip, Schlabitz introduced young Harris to the poet, painter, and philosopher Paul Thiem, who scoffed at orthodoxy. Harris, brought up as strictly as he had been, found the idea shocking, and even stirring.

The few works that survive from Harris's years as a student are of urban or landscape subjects, realistic in treatment and lonely in mood. The watercolour *Interior with a Clothes Closet* (below), dated February 1906, shows his keen eye for the particular and an ability to find beauty in the commonplace. This depiction of an everyday scene and inanimate objects, likely painted in the studio in which he worked, has a sense of delight in observation. Harris recorded the

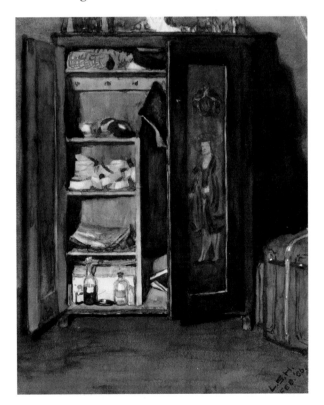

Interior with a Clothes Closet 1906

Watercolour on paper; 31.0 x 24.8 cm

Buildings on the River Spree, Berlin 1907

Watercolour mounted on cardboard; 59.7 x 45.6 cm

subtle differences between one shelf and the next, revealing an expressive hand. In other works of this time, Harris drew street scenes in Berlin, sometimes with deep spatial composition. In one watercolour, *Buildings on the River Spree, Berlin* (opposite page), the composition is developed through layers, a technique characteristic of his later work.

Before returning to Toronto, Harris visited Italy, France, and England. In Italy he met the expatriate Canadian writer (also from Brantford), Norman Duncan. Duncan was preparing a series of eight travel articles, an account of a camel caravan from Jerusalem to Damascus, for *Harper's Monthly Magazine*. He invited Harris to travel with him to the Middle East to prepare the illustrations. The trip lasted six weeks, and the following year the articles were published in book form – with a selection of illustrations – under the title *Going Down from Jerusalem: The Narrative of a Sentimental Traveller*. Harris's work, which he later dismissed, consists of careful portrayals of individuals or scenes. In the frontispiece, *Over the Old Route into Egypt*, Harris experimented with contrasting colours, showing the influence of postimpressionism.

Harris returned to Canada in 1908. He was not yet an artist in the real and creative sense, but he brought with him from Europe a solid academic training and a knowledge of avant-garde art. He would find his inspiration in Canada.

RETURN TO TORONTO

In Toronto, to which he returned in 1908, Harris quickly discovered kindred spirits through the Arts and Letters Club, which he helped found that year in a building on Court Street. Harris entered fully into the life of this important club: he played the violin in its orchestra, designed sets for its theatre productions, and wrote a review article for an ambitious club project, *The Year Book of Canadian Art, 1913*. Later, he recalled that the club offered the members the opportunity to meet representatives of all the arts.

One of the most influential and progressive members of the club was Roy Mitchell, who promoted experimental ideas in drama and was active in Toronto until 1914, when he went to New York to direct the Greenwich Village Theatre. In 1919 he returned to Toronto to become artistic director of the new Theatre at Hart House. It was likely Mitchell, also a founding member, who encouraged Harris to design the sets for club plays. Later, Harris remembered Mitchell as the person who had introduced him to Plato and esoteric Eastern texts. Mitchell, who had wide-ranging interests, was a member of the Theosophical Society of Toronto, a group that later became vitally important to Harris.

In 1910 Harris married Beatrice (Trixie) Phillips. After the honeymoon, the young couple returned to a house on Clarendon Avenue in a comfortable Toronto neighbourhood.

But despite being married and from a socially prominent family, art was to be Harris's life. The impact of returning to Canada was immense: he saw the land-scape with fresh eyes and new insight, becoming aware of the extravagant energy of this continent. The quality and clarity of the light excited him. In 1910, he took the first serious step of the real artist and rented a studio – a room over Giles's grocery store just north of Bloor Street on Yonge Street.

In this studio, he painted *Houses, Wellington Street* (p. 17), the work that brought him his first success as an artist. This painting, which he exhibited with the Ontario Society of Artists in March 1911, with its power and ease, announces what Harris intended to be as an

artist: a leader, who based his subject on Canada. Like his work in Berlin but much grander in its concept, the painting has a layered composition. Now the viewer looks through a screen of trees parallel to the picture plane to see a row of red-brick houses and, in front of one, a horse-drawn sleigh. Harris's handling of light has changed. In *Houses, Wellington Street,* he uses an almost spotlit effect to pick out certain areas. This effect, along with the strong interplay of horizontals and diagonals, seems to reveal Harris's interest in Vincent van Gogh, whom he had discovered in Berlin. As in his earlier watercolour *Interior with a Clothes Closet,* what registers initially is what Harris called later, "copying nature." But we also feel his intense interest in design and texture. "A masterpiece," the critic Augustus Bridle wrote in the magazine *Canadian Courier,* noting how convincing it looked. Harris's enhanced stature in the cultural community was not long in coming. The Ontario Society of Artists elected him a member. It was a sign of his growing importance to Canadian art. Later in his life, Harris continued to express his admiration for this work. He used the painting to represent his early work in two retrospective exhibitions. It was, for him, a landmark.

A work such as this painting, with its elegance and sophistication, would have interested one of his new friends, J.E.H. MacDonald, later to be one of the architects of the Group of Seven, whom he met in November 1911 at an exhibition of MacDonald's work at the Arts and Letters Club. The meeting with MacDonald was momentous. The following months in *The Lamps,* the magazine of the Arts and Letters Club, painter and illustrator C.W. Jefferys reviewed MacDonald's show, stating that the exhibition allowed MacDonald's peers their first opportunity to estimate his powers in landscape painting. MacDonald's art was native, Jefferys explained; as native as the rocks, the snow, the pine trees, or the lumber drives that were so largely his themes.

What was important to Harris about MacDonald's paintings was their spirit. Later, Harris was to say, "I was more affected by these sketches than by any paintings I had seen in Europe."

MacDonald was born in Durham in England. He arrived in Canada at the age of fourteen, then studied art at the Hamilton Art School and in Toronto at the Central Ontario School of Art. After working as a graphic designer at the lively and ambitious commercial art firm of Grip Limited in Toronto, he returned to England. He was a devoted reader of Thoreau, one of Harris's favourite writers. MacDonald and Harris became close, and in a measure of any artist-friendship they began to take sketching trips together. Harris would remember MacDonald as his first sketching friend. Sometimes they both painted the same scene; one important example is the gas works in Toronto, which they visited during the winter of 1911–1912.

Harris's *The Gas Works* (p. 18), the picture he developed from the experience, is an excellent example of the taste prevailing in Canada at the turn of the century. Harris's style has been called "tonalism" because of its soft muted colours and tonal effects. At this moment, his sensibility, rather hesitantly, showed the influence of impressionism, and in this subdued scene the viewer finds impressionism's concern with the transient effects of smoke and clouds. But Harris was a tonalist too, emphasizing a dreamy moodiness through a diffusion of light, softened outlines, and a richly built-up paint surface of melded colours such as pink, grey, and brown. In a way, in this painting and in other works of the same period, he had taken a step backward from *Houses, Wellington Street,* with its clarity of light. That autumn, in paintings such as *The Drive,* he would return to the brighter colour and brilliant light and spotlit effect of *Houses, Wellington Street.*

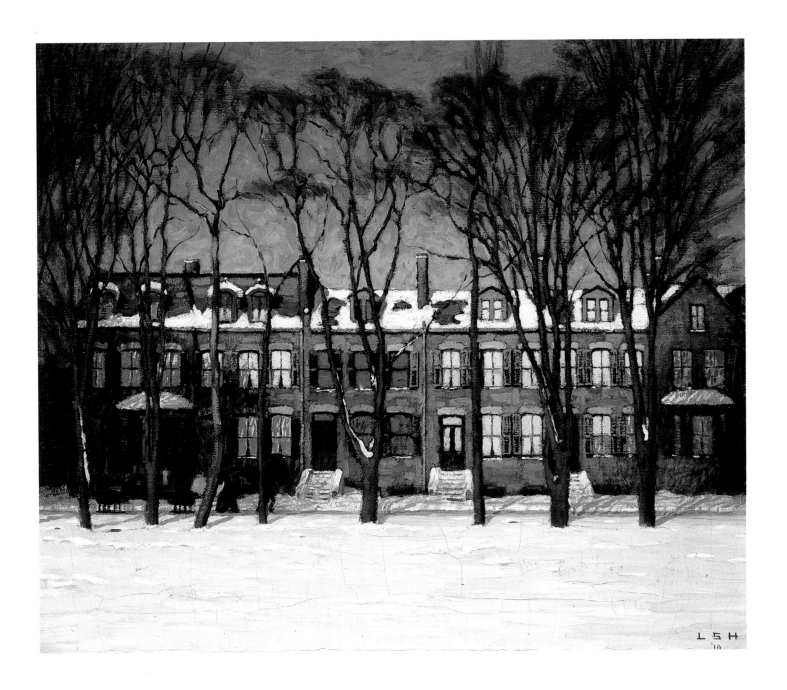

Houses, Wellington Street 1910

Oil on canvas; 63.5 x 76.2 cm

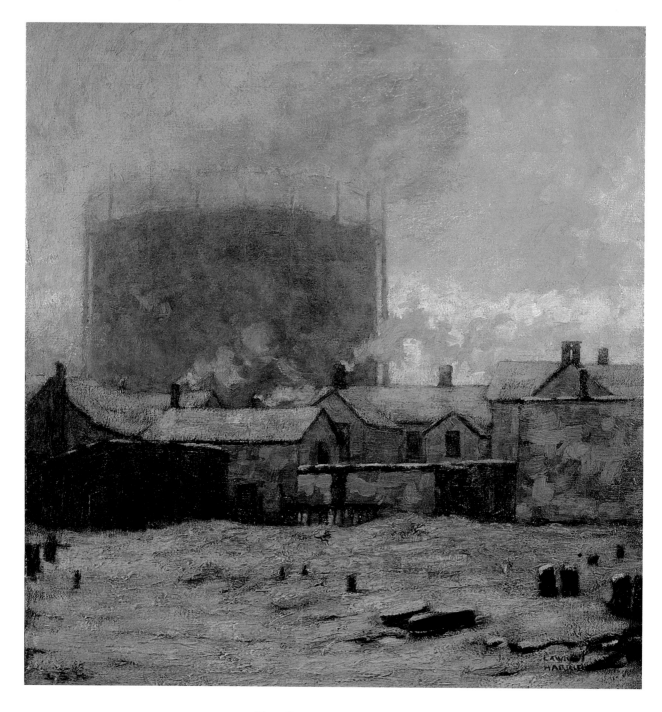

The Gas Works 1911–1912

Oil on canvas; 58.6 x 56.4 cm

The Drive (p. 20) is Harris's first monumental Canadian landscape and his first to depict Northern Ontario. The painting is of five lumberjacks on logs, hard at work. It was developed from sketches made on trips with MacDonald to Mattawa, Burks Falls, and other places in Northern Ontario. In it he used his "spotlit light" effect, which falls in the middle ground and part of the background, illuminating the pinks and blue of the snow and the golds and browns of the trees. The painting reveals that Harris at this stage of his life chose to represent the scene much as he must have seen it. He recognized that in snow could be found all the colours of a prism. Later he was to say, "There is so very much in whiteness."

Harris was not alone in his choice of a northern subject. At MacDonald's exhibition, Harris had met Tom Thomson, MacDonald's friend and fellow staff member at Grip, where MacDonald was head of the design section. Later, at the Arts and Letters Club, Harris met Arthur Lismer, Franklin Carmichael, and Frank H. (later Franz) Johnston; all would be founding members of the Group of Seven in 1920. As a group, these men would take giant strides in the direction of a national art.

Thomson took the first steps. In the autumn of 1912, he returned from a sketching trip in the area of Ontario's Mississagi Forest Reserve, west of Sudbury. Dr. J.M. MacCallum, an ophthalmologist – and friend of Harris's – who taught at the University of Toronto, found Thomson's sketches true to the grim, fascinating northland. Such sketches as we can identify from the trip have simple motifs and show a sensitivity to the crude terrain. Harris no doubt admired such work. Thomson was an artist with Ontario roots. He was born at Claremont, near Toronto; then his family moved to Leith, near Owen Sound. He worked as a commercial artist in Seattle, but returned to Toronto in 1905 and began to take art seriously.

Lismer, another staff member at Grip, was born in Sheffield, England, and studied at the Sheffield School of Art and at the Académie Royale des Beaux-Arts in Antwerp, Belgium. Carmichael, also at Grip, had studied part-time at the Ontario College of Art and at the Toronto Technical School. Johnston, another member of the Grip firm, had attended the Ontario College of Art and the Pennsylvania Academy. All three men became Harris's friends. In 1912 Harris met Fred Varley, newly arrived from England. Varley, like Lismer a native of Sheffield, had come to Toronto to work at Grip. Also like Lismer, he had been educated at the Sheffield School of Art and the Académie Royale des Beaux-Arts in Antwerp. In 1913, one more person joined the band that was forming: A.Y. Jackson, who had studied in Montreal, in Chicago at the Art Institute, and in Paris at the Académie Julian.

The north country was the key to what would become the new Group. Later, Harris was to believe that the inspiration was Canada itself; to paint it was the real incentive. By 1913, although the Group itself was only in the formative stages, Harris was caught up in the sheer excitement of love of the land and in the very act of painting. An activist by nature, he felt a call and responded. Like his preacher forefathers, he had a mission. His was art.

His interest extended to practical matters. In January 1914 he and Dr. MacCallum opened the Studio Building, where all the artists could work together. The three-storey building on Severn Street, within walking distance of Harris's old studio near Bloor and Yonge streets, quickly became a lively centre for new ideas, discussions, plans for the future, and visions of an art inspired by the Canadian countryside. Without Harris, there would have been no Group of Seven. As A.Y. Jackson acknowledged: "He provided the stimulus; it was he who encouraged us always to take the bolder course, to find new trails."

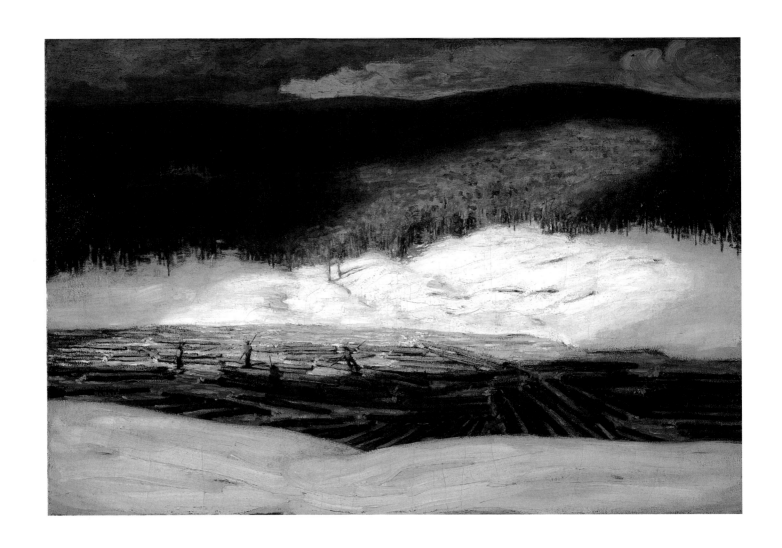

The Drive 1912

Oil on canvas; 90.7 x 137.6 cm

Two: The Formative Years

Harris regarded the period of his work from 1913 to 1918 as a preliminary stage, but it contains some of his most beautiful canvases. He described the treatment he applied to them as "decorative," since he used brush strokes and heavy paint to enliven the surface of the canvas while juxtaposing contrasting colours, the mark of the postimpressionist. He painted these works both in urban areas and in what appears to be wilderness, though Toronto's High Park and ravines sometimes provided the rustic settings.

Like every true artist, in creating his work he absorbed outside influences. One such influence was the "Contemporary Scandinavian Art" exhibition that he and MacDonald visited in January 1913 in Buffalo, New York, at the Albright Art Gallery. He and MacDonald were thrilled by the "northernness" of the paintings they saw there, especially by the work of such artists as Harald Sohlberg and Gustav Fjaestad, as we know from annotations in MacDonald's catalogue. In 1948, Harris wrote that the trip turned out to be one of the most stimulating and rewarding experiences either of them had had. Here were a large number of paintings that gave body to their nebulous ideas; paintings of northern lands created in the spirit of those places. Here was a landscape as seen through the eyes, felt in the hearts, and understood by the minds of people who knew and loved it. Here was an art, bold, vigorous, and uncompromising, embodying direct experience of the great north.

Their enthusiasm and determination grew as a result of their experience in Buffalo. From that time on they knew they were at the beginning of an all-engrossing adventure. That adventure, as it turned out, was to include the exploration of the whole country for its creative and expressive possibilities in painting. As MacDonald would later say in a lecture, from the Scandinavian exhibition they learned how they wanted to paint Canada.

Both of them particularly noted the decorative treatment used by the Scandinavian artists: the way colour and drawing were transformed into design. MacDonald would have found here echoes of art nouveau, one of the greatest innovations in the history of design, with its easily identifiable curvilinear, or whiplash, motif and undulating rhythmic pattern. But more important was the general effect created by abandoning a too-literal interpretation of nature.

Harris's painting during this period, as in the foliage and scattered autumn leaves of *Hurdy Gurdy* (p. 23), shows the influence of the Scandinavians. His snow scenes in particular fuse naturalistic and stylistic motifs, sometimes even to the point of recalling Fjaestad's depiction of snow and snow-laden fir trees. Like Fjaestad, Harris used a pointillist effect. Bold touches of related colour and clearly defined brush strokes, placed side by side and following the form, created a variation in the soft, radiant colour combinations of pinks, purples, yellows, greens, and cream.

There were other influences that contributed to his work at this moment. We can only speculate that Harris visited New York as early as 1908. (We know that later on he often visited galleries there.) The photographer Alfred

Stieglitz opened his Gallery 291 that year (at 291 Fifth Avenue), where he promoted European and American modernism. At 291, as the gallery was popularly known, Stieglitz presented one-person exhibitions of avant-garde artists. These shows, which continued until the gallery closed in 1917, would have reaffirmed Harris's interest in postimpressionism.

Harris must have decided that, for the moment, he wanted to work more with colour harmonies than with brilliant colour. Several of his works of the period, such as *Snow II* (p. 24), *Spruce and Snow, Northern Ontario* (p. 25), *Autumn [Kempenfelt Bay, Lake Simcoe]* (p. 26), and *Snow* (p. 28), reveal his continued reliance on the principles of decorative design. In paintings such as these, he favoured the use of a rich range of tints to record the brilliant effects of Canadian light. These he combined with a strong structural component. The paintings work in a layered way, through light: well-lit foreground, somewhat darker middle ground, and light in the background. The distinct colour changes add to the effect of careful plotting and strong execution. The impact is heightened by the broad strokes of paint, the stylized forms, the rich pattern of the imagery, and the restricted but lyrical colour range, one gentler and more subtle than in *Laurentian Landscape*. In *Autumn [Kempenfelt Bay, Lake Simcoe]*, for instance, Harris painted maples with colours of coral, pink, and lavender; creamy birch trees spotted with brown and black; a sky of turquoise blue overlaid with pink, turquoise, and cobalt water; and brown rocks overpainted with cream, white, and green. In the picture, the distant shore of brown hillside and green trees is overlaid with gold. *Snow* has a similar colour magic: lavender, blue, and pink snow; tree trunks of lavender; and, in the distance, dark blue with red dots.

By 1917, Harris's attention extended to the North American art movement known as "synchromism." He knew about synchromism through the publications of American art critic Willard Huntington Wright, who championed pathfinders among the postimpressionists, especially Cézanne. Harris may have conceived of his canvas *Decorative Landscape* (p. 27) as an attempt at capturing chromatic excitement. In this emblem of the northern experience, he used layers of different forms to create the composition: first, rounded rocks of red, overpainted with purple and light blue; second, dark blue- and dark green-coloured spruce, set in front of a sunset sky of light yellow, pale blue, and pink that fades to a rich gold at the horizon line of pink and blue hills. The water too has a gold hue. The result captures Harris's colour genius at its height.

When Harris showed the painting at the exhibition of the Ontario Society of Artists in March 1917, critic Hector Charlesworth wrote in *Saturday Night* that the general effect was that of a garish poster. The critic for *The Mail and Empire* responded more favourably, but even he felt it was not Harris at his best. Today we appreciate the brilliant mixture of colours and strong contrasts. The glimpse through trees of the shoreline on the distant horizon is like a look at a promised land.

Harris was probably provoked into painting so emphatically by feelings that the First World War stirred in him. But during the years 1917 and 1918, two events combined to give him a knock-out blow. On July 8, 1917, Tom Thomson died in Algonquin Park, and in February 1918, Harris's brother Howard was killed in action. As a result, Harris's health gave out. He suffered a nervous breakdown. Later, he wrote MacDonald some of the symptoms: troubled sleep, terrified tossing, apprehensive feelings. He felt disoriented and that his life was futile. It was during his period of recovery, in the spring of 1918, that in the company of his friend Dr. MacCallum he first travelled to Algoma. That autumn he went sketching there again, now accompanied by MacDonald, Johnston, and MacCallum. The years from 1918 to 1930 mark the first period of his major work as a landscape painter.

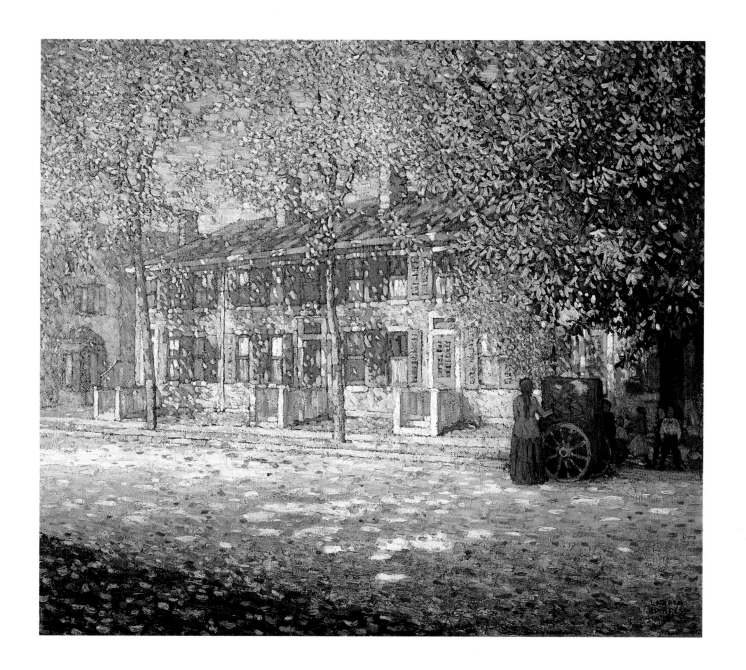

Hurdy Gurdy 1913

Oil on canvas; 75.8 x 86.6 cm

Snow II 1915

Oil on canvas; 120.3 x 127.3 cm

Spruce and Snow, Northern Ontario 1916

Oil on canvas; 102.3 x 114.3 cm

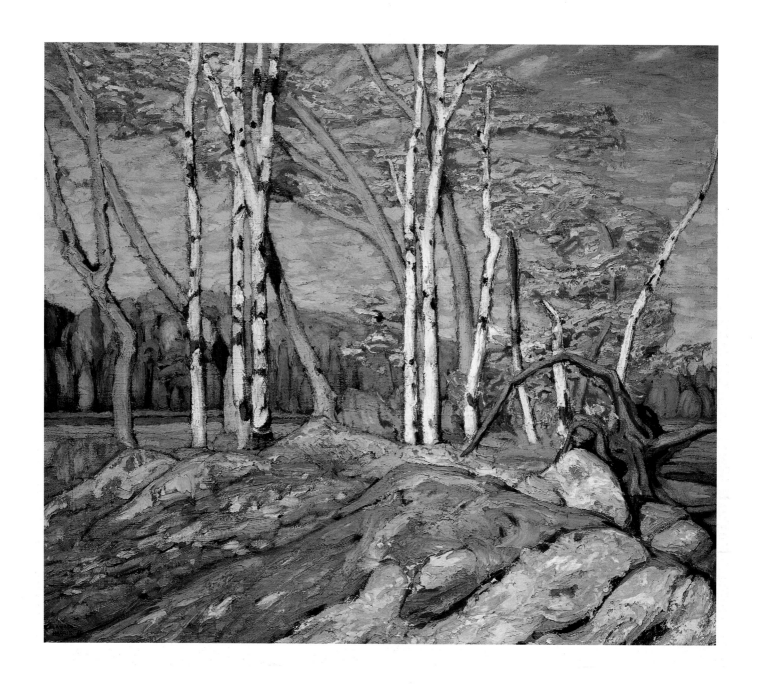

Autumn [Kempenfelt Bay, Lake Simcoe] undated [c. 1916–1917]

Oil on canvas; 97.5 x 110.0 cm

Decorative Landscape 1917

Oil on canvas; 122.5 x 131.7 cm

Snow c. 1917

Oil on canvas; 71.0 x 110.1 cm

Three: The Fertile Years

Harris's "classic" landscape period occurred over a twelve-year span, during which three critical events occurred in his life: his introduction to the region of northern Ontario known as Algoma (where he made eight sketching trips between 1918 and 1924); the formation of the Group of Seven, which was founded in 1920 and held its last exhibition in 1931; and his involvement in the Toronto Theosophical Society, which he formally joined in 1923. These events have a bearing on one another. His discovery of Algoma and then the north shore of Lake Superior gave him a rugged, wild land with amazingly varied scenery; the support given by the Group of Seven led to some of his finest work; and his interest in theosophy provided a spiritual insight that he wished to convey in paint.

Harris described this period as "organization in depth," and his paintings are differently organized than in his earlier work. Now he sets his forms more firmly in a space often created by a darkened foreground and a brilliantly lit background. In *Elevator Court, Halifax* (p. 36), for instance, Harris created an effect of deep space by recording in perspective the receding sides of boxy tenements. In this arresting composition, he negates the leap into depth through the use of the Chebucto ironworks smokestack in the background, set at the end of the elevator court. As in his decorative period, he continued to use rich colour. *Elevator Court, Halifax* would seem plain without the thrilling harmony achieved through the dramatic sky of approaching evening with its yellow clouds pierced by shots of blue; the distant blue water; and the boldly painted areas of

snow with blue meltoffs in the foreground. In contrast to his earlier paintings, the brushwork is smooth. The painting has an almost austere clarity, intensified through the use of a black line around various areas such as the distant land. With the quality of light, there is absolutely nothing pedestrian about the scene. *Ontario Hill Town* (1926) has a similar firm structure, as does *Red House, Winter* (p. 37).

ALGOMA

A key location in Harris's development was the Algoma region of Northern Ontario and places such as the magnificently scenic Agawa Canyon 182 kilometres north of Sault Ste. Marie. Harris's exploratory trip to Algoma inspired him to outfit a boxcar as living quarters and take painter-friends, including MacDonald, on a serious painting trip. In 1918 the Algoma Central Railway helpfully moved the boxcar from place to place. This trip, and successive ones to the same area and to other areas of Canada, developed the Group's sense of community spirit as well as affirming that their art was to be oriented to the North and to the discovery of Canada. We can see the effect on Harris in his painting *Beaver Swamp, Algoma* (p. 33), a scene of the woods at night in a sort of *Evening Solitude,* as he titled another of the Algoma oils (1919). In *Beaver Swamp,* the sun sets on a silent scene in a tangled swamp, producing an eerie quality intensified by the spectral glow of light from the sky. The handling of the paint is vigorous, rough, and thick. The way Harris

painted the screen of trees in a wall of wilderness may recall an idea of Thomson's, one from *Northern River*. Harris also may have drawn upon Thomson's idea of using a dark red undercoat of pigment in *The Jack Pine*, but Harris intensified the vibrant result by overpainting red with colours such as turquoise and gold. That he seems to recall Thomson at this moment may suggest he was thinking of this great artist as he and his friends gathered their strength for a united effort.

THE GROUP OF SEVEN

The First World War had intensified Harris's ideas of what he wanted to paint. Simply, he wanted to express what he felt about Canada. His reaction was characteristic of many Canadians of the times, who responded to the futility of war with a desire to discover their own country. Only a new and properly organized spirit could make a new Canada work, he and others believed. For this enterprise, Harris had the necessary enthusiasm, knowledge, and money. Unofficially, he became the leader of a friendly alliance for defence (as they described it), which also included Franklin Carmichael, A.Y. Jackson, Frank (later Franz) Johnston, Arthur Lismer, J.E.H. MacDonald, and F.H. Varley.

A drawing Lismer sketched in March 1920, the night the Group was christened at Harris's home at 63 Queen's Park in Toronto, shows Harris's energy. Still young (he was thirty-five), insouciantly smoking a cigarette, and completely at ease, Harris is sprawled on a wicker armchair in his living room as he talks with friends. (See p. 54.)

The Group's name probably came from Lismer. He apparently mentioned it to Harris, perhaps the night in March when he wrote it on one of his drawings. Lismer had recently worked in Halifax, the home of an artist named Ernest Lawson. Lawson was a member of the rebel American movement known as the Eight (also called the Ashcan School). Harris would certainly have recognized the suitability of the name from similar groups he had seen, or of which he would have heard, in Berlin.

Once these artists became a group, what they shared lasted only briefly for some of them. Membership was flexible and exhibitions varied as different painters showed with the Group. Through the years three new members were added: A.J. Casson, Edwin Holgate, and L.L. FitzGerald. Other spirited newcomers, such as Yvonne McKague Housser and Isabel McLaughlin, were invited as contributors. The imagery in Harris's pictures and those of other members changed over time. Catalogues of successive shows indicate a change from subject to technique, from a glorification of Canada's natural environment to encouragement of experiment.

Although the Group prided itself on having no officers and no formal structure, it did have certain qualities in its painting style. Along with Thomson, who died before the Group was formed, their paintings depict – with optimism and vigour – a land of bold effects, powerful weather conditions, and northern vastness. Group work shows a direct reaction to nature and is full of the flavour of Canada. It has strength and follows faithfully all the seasons, with a broad, rich treatment. Its forms are architectural and massive. The key ideas were grandeur and beauty; an intensification of the subject; a sense of the sublime; and vastness, majesty, dignity, austerity, and simplicity. Handling was powerful and brisk. MacDonald told students, "Think big, be generous, don't fiddle, enlarge yourselves."

In selecting their subjects, the members of the Group represented the culture of their period. With the choice of an outdoor scene came a certain spiritual quality, mental associations of peace, and boundless aspirations. The sense of a divine presence could be experienced in nature. The landscape was religion, a kind of pantheism.

The audience sensed it. Harris in particular had developed a mystical vision of nature from reading philosophers and mystics. In the 1920s he combined Canadian landscape forms with generalized spiritual ideas. The images in his paintings, often of mountains, seemed symbolic of artistic striving. As he explained, if we view a great mountain soaring into the sky, it might evoke within the viewer an uplifted feeling. "There is an interplay of something we see outside of us with our inner response," Harris wrote. "The artist takes that response and ... shapes it on canvas with paint so that when it is finished it contains that experience" (Bess Harris and R.G.P. Colgrove (eds.), *Lawren Harris*, p. 76).

The austere, intellectual quality of Harris's thinking is expressed in his work, in which he used a spare type of composition, a restricted palette, and smooth brushwork. He simplified nature to lucid fundamental forms. ("Art Is the Distillate of Life," is the title of one of his essays.) He stressed the contours of the land, its essential shapes. He also used light suggestively, almost as though it were a metaphor for something else. (He might have called it the presence of the informing spirit, a concept recalled from his esoteric studies.) *Above Lake Superior* (p. 35) is pivotal in his development. It marks a turn away from his earlier work, the decorative phase, to a new phase that would lead, in increasing steps, to abstraction.

Harris discovered the north shore of Lake Superior with Jackson in 1921 and quickly realized that he had found his perfect painting country. (He would visit it

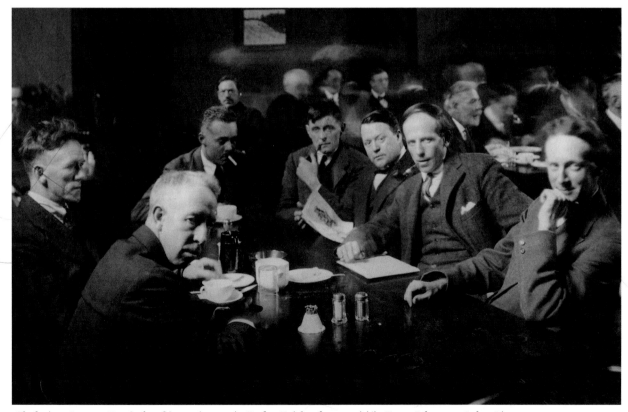

Six of the founding members of the Group of Seven seated around a table at the Arts and Letters Club, Toronto, c. 1920. (Absent: Franklin Carmichael.)

Clockwise: Lawren Harris (smoking a cigarette), Barker Fairley (an art critic), Franz Johnston, Arthur Lismer, J.E.H. MacDonald, A.Y. Jackson, F.H. Varley.

again in the autumns of 1924 and 1927.) In 1922 he discovered Coldwell and nearby Pic Island, about half the journey west along the north shore from Sault Ste. Marie to Thunder Bay, which also became favourite painting places. Lake Superior fulfilled his desires for a simplified, pared-down land, with an effect of grandeur. The water seemed to stretch to infinity. Jackson, who was with him on many of his trips there, later recalled the impressive scenery and what he called the sublime order to the long curves of the beaches, the sweeping ranges of hills, and the headlands that push out into the lake. *Pic Island,* as Harris painted it (p. 38), has a sculptural form. The humpy island is shaped like some animal that seems to crouch on the surface of the water.

At the time he painted Lake Superior in *Above Lake Superior,* Harris was becoming increasingly involved with theosophy. He saw through it a way to convey a subtle lesson about nature and the supernatural rolled into one. He reached for one of the pencil-and-oil sketches he had drawn of birches on a snowy hillside looking down on Lake Superior. Then he reworked it slightly, making the clouds into a series of receding bands and adding jostling orange treetops to the lower slopes of the purple and green hill, which probably looked too bare without them. He conveyed the spiritual essence of the scene through the sharp white light that falls on the birches and snow. Perhaps the light suggested something about theosophy, which adherents believe is represented by the white light of pure truth. Still, Harris was never didactic in his work as a painter.

In other works, such as *From the North Shore of Lake Superior* (p. 43), Harris again used the landscape around Lake Superior to depict both natural phenomena and other-worldly interests, and used space and movement

to underline a higher concern with the soul. He had read deeply in transcendental literature and believed in the immediate presence of eternity. Note the curtain of cloud which lifts to show a distant horizon. This popular Victorian motif was often used by the Group of Seven.

Some critics consider *North Shore, Lake Superior* (p. 2) to be the most remarkable work of Harris's career. For them it is an icon combining the natural and the spiritual. In this work, a stump is set high on a rocky shore above Lake Superior. In the distance is a bank of clouds that encircles a flow of illumination from an unseen source. Harris discovered the motif on a trip to the Coldwell area with Jackson in 1925. For some viewers, it represents the essence of spiritual life. Jackson later recalled that the stump was almost lost in the bush, nowhere within sight of the lake, but Harris isolated it and gave it a nobler background, exaggerating its three-dimensional quality to create an elegant painting. There probably was a long process of refinement. Harris wrote of the great North, describing "its implicit loneliness and replenishments, its resignations and release, its call and answer – its cleansing rhythms." He gives his own words visual form in this canvas.

The painting was quickly recognized as a classic statement of the Canadian North. Some critics even suggest that it is a reference to Harris's personal journey – his gradual healing after the nervous break-down he suffered in 1918 – and find anthropomorphic references in his Lake Superior work. Likely, Harris's intention was not so specific. In his art he sought to convey a universal presence by reducing life to a perfectly composed miniature. In his later paintings of Lake Superior, Harris's forms become increasingly abstract. He continually strove to express, ever more intensely, a spiritual and mystical quality.

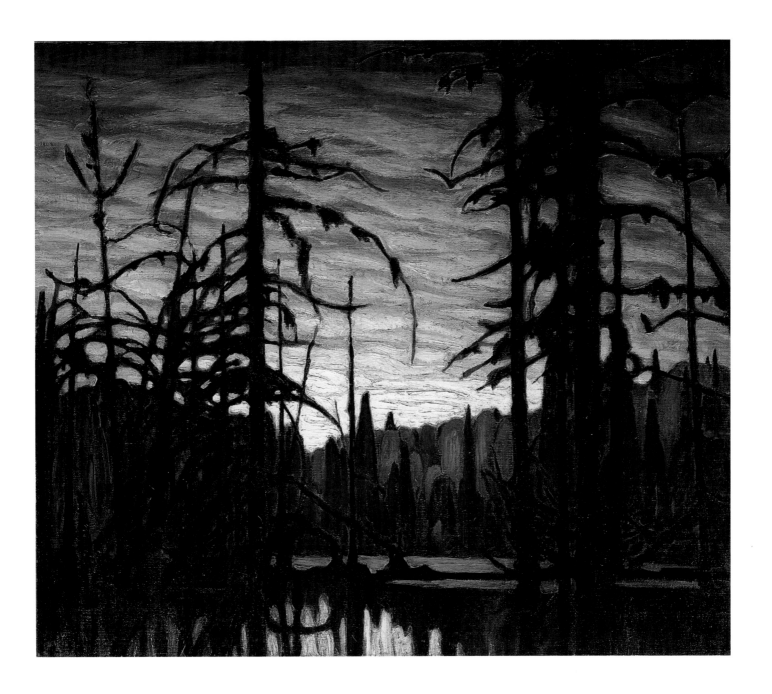

Beaver Swamp, Algoma 1920

Oil on canvas; 120.7 x141.0 cm

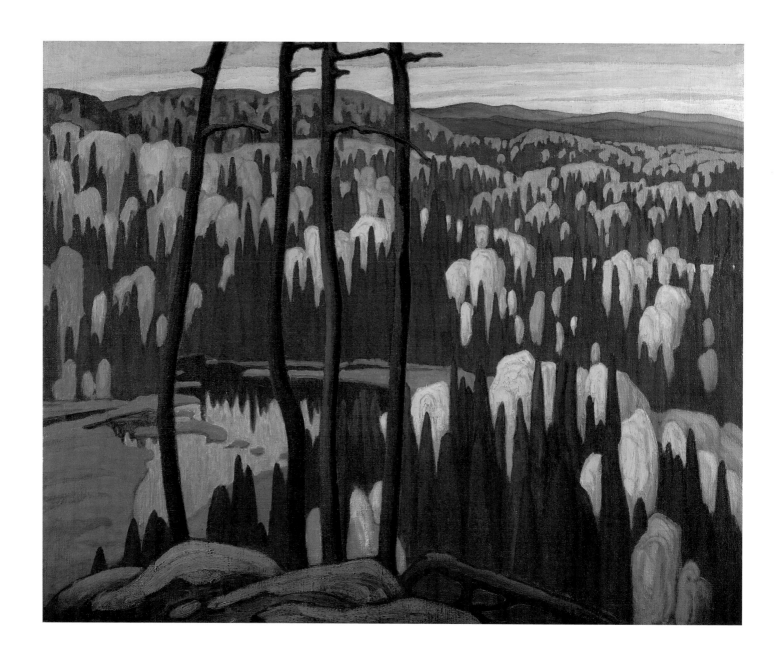

Algoma Country 1920–1921

Oil on canvas: 102.9 x 127.5 cm

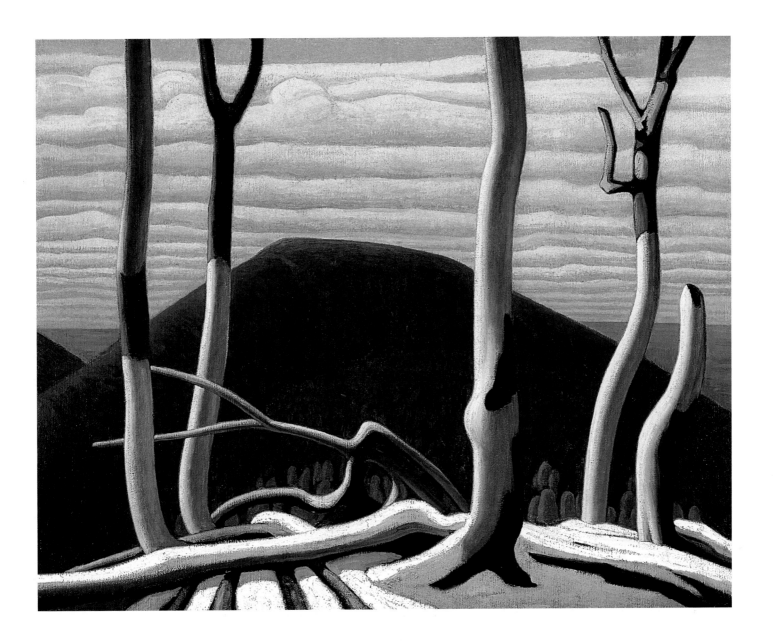

Above Lake Superior c. 1922

Oil on canvas; 121.9 x 152.4 cm

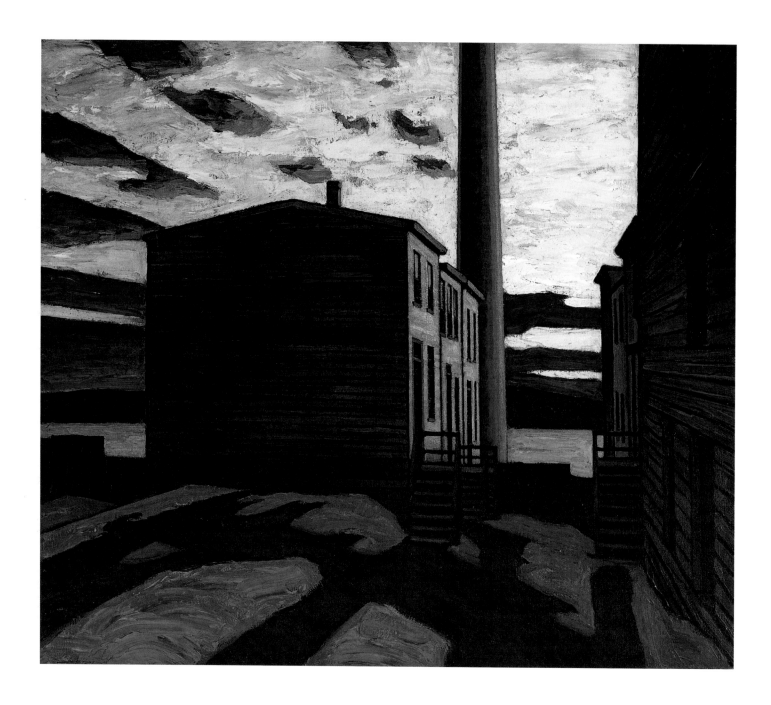

Elevator Court, Halifax 1921

Oil on canvas; 96.5 x 112.1 cm

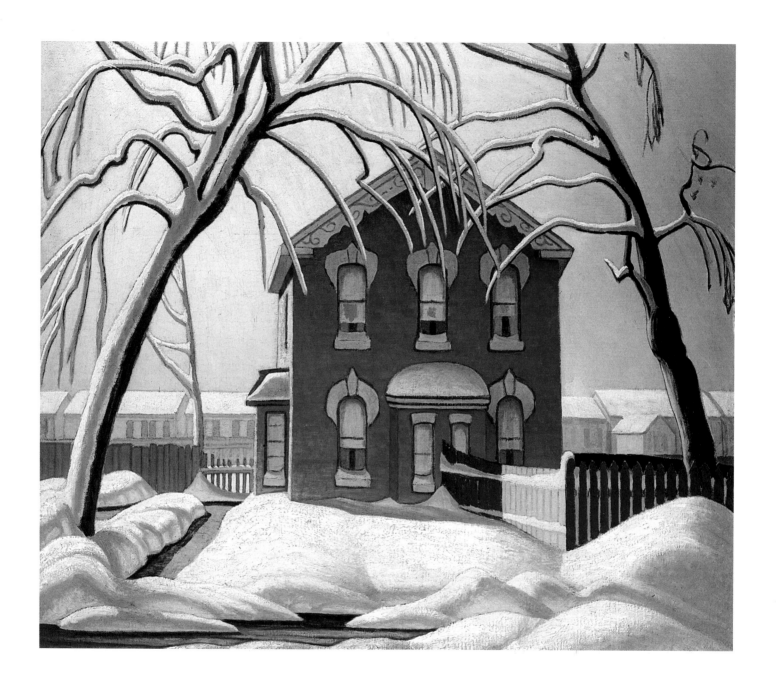

Red House, Winter c. 1925

Oil on canvas; 84.5 x 97.5 cm

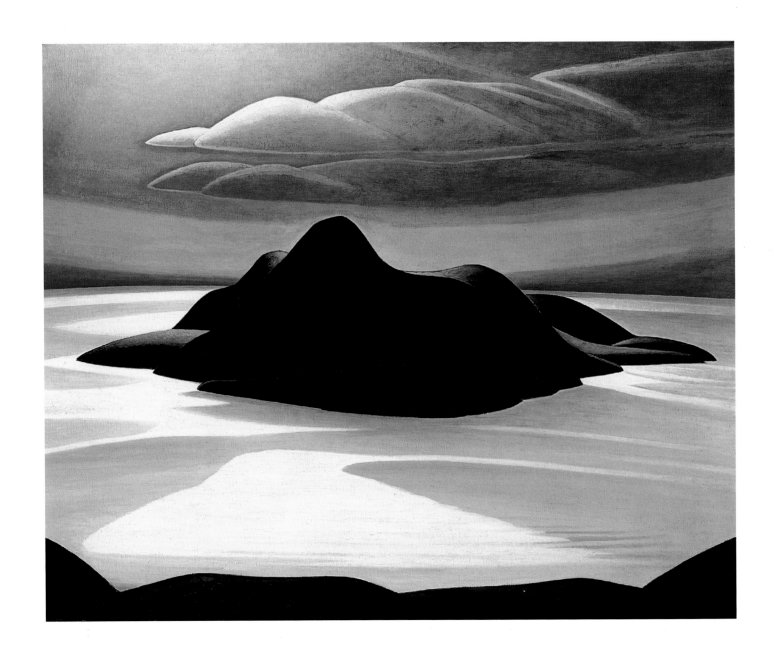

Pic Island c. 1924

Oil on canvas; 123.3 x 153.9 cm

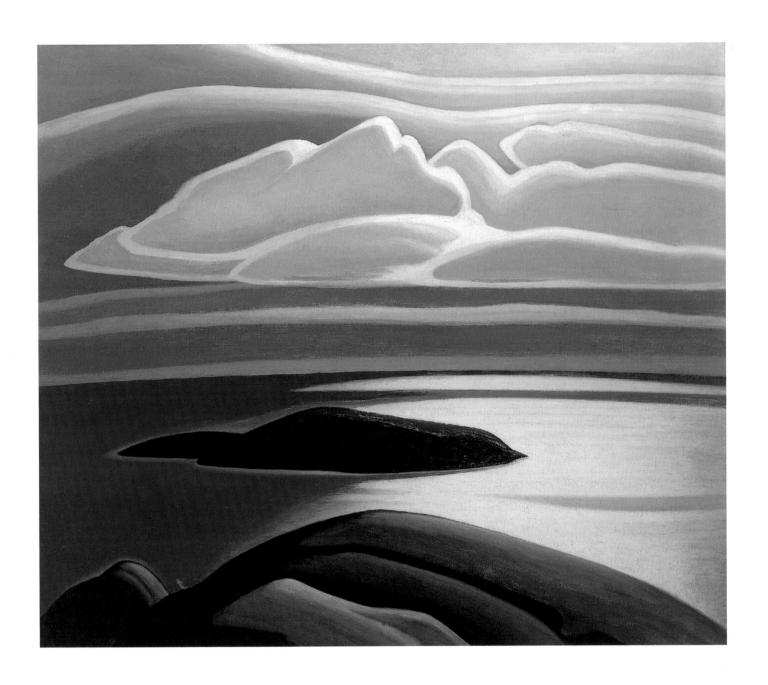

Morning Light, Lake Superior c. 1927

Oil on canvas; 86.5 x 102.0 cm

Another great subject for Harris in these years was the Canadian Rockies, which he visited every summer between 1924 and 1928. He found in them power, majesty, and a wealth of experience – and he enjoyed mountain climbing as a way of testing his muscular responses, as he had in his youth. In 1924 he painted *Maligne Lake, Jasper Park* (opposite page). Harris is to some extent as important an artist of the Canadian West – of western light, western space, western silences – as he is an heir to Tom Thomson. He has captured in the scene an extraordinary sense of stillness, reinforced by his colour range of greys and blues and the painting's compositional balance. A later work, *Isolation Peak* (p. 48), carries the story one step further, with its explicit contours of the land, the floodlit pyramid-shaped peak, and the sense of quiet serenity. Harris may have begun this work with a reference to a peak in the Collins Range, near Maligne Lake. There is no "Isolation" mountain. He has painted here a universal form to represent things of the spirit.

The culmination of this attitude of mind is his painting *Lighthouse, Father Point* (p. 47), a subject Harris discovered one dark, cloudy day at Métis Beach, east of Rimouski, Quebec, on the south shore of the St. Lawrence River. In the harbour village of Father Point, west of the beach, he found a modern concrete light-house. He made several detailed pencil drawings, and from these sketches he painted a small, simplified oil study before developing his large canvas. The beam was not activated when he was there, but in the sky he painted a soft welling light that seems to radiate from the lighthouse.

For Harris, the structure was a majestic embodiment of transcendental thought. The painting glows with a supernatural calm.

In other works, which he developed from a trip to the Arctic in 1930, Harris selected natural objects such as icebergs, shaped by nature into mysterious forms. *Greenland Mountains* (c. 1930) shows us a world with enchanting blue icebergs floating to a frozen ice field of formal simplicity. The appeal lies in the majestic natural architecture and eloquent calm of the scene: Harris was leaving naturalism behind.

By the late 1920s, he was beginning to experience uncertainties about his work. He wanted to move ahead, but did not know in which direction. So much of his work had been based on a theme of the North, yet he yearned for a change – in his work, and in his life too. Out of his feelings of confusion grew a long correspondence with Emily Carr, whom he had met for the first time in 1927. In encouraging her with her work, he confided his personal thoughts about art and life. But though he was able to convey such private thoughts to her, the friendship did not ease his frustrations. The result was that in 1932 he did something which artists call stonewalling and regard as close to death. He stopped painting for a period of two years.

THEOSOPHY

Harris was keenly interested in theosophy, a synthesis of religions tied to Eastern beliefs that deal with ethics, art and aesthetics, and moral codes. He believed that the human being is composed of layers of reality. A person's real being exists in the realm of the spirit, which can be perceived by the awakened soul. The layer of least value is the physical. He had fallen under the spell of the nineteenth-century Anglo-Russian author Helena Petrova Blavatsky, co-founder in 1875 of the burgeoning Theosophical Society and the writer of *The Secret Doctrine: The Synthesis of Science, Religion and Philosophy* (1888) and other books that plagiarized esoteric texts. Madame Blavatsky had suggested that theosophy is the primordial wisdom-religion, the

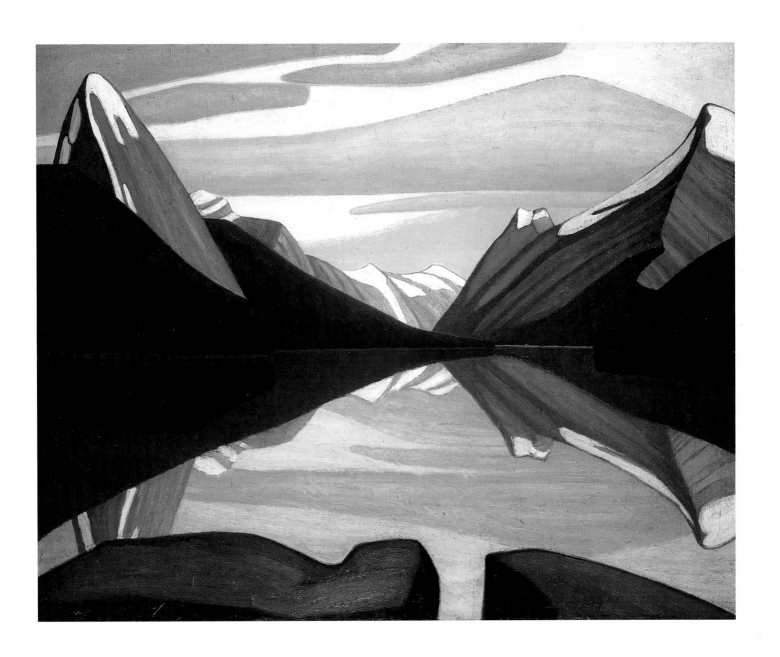

Maligne Lake, Jasper Park 1924

Oil on canvas; 122.8 x 152.8 cm

secret doctrine that underlies all existing religions and scriptures. Her books are based on reincarnation and karma (the unerring law that restores and maintains equilibrium in the universe); planes of being; and nirvana (the view that, after death, human beings participate in an ego-dissolving return to a divine principle).

Harris deeply believed in theosophy, to such an extent that he wrote for *The Canadian Theosophist*, read papers at conventions, and gave radio talks on the subject. He bothered his friends by zealously handing out or sending them literature about the society. (Some returned their pamphlets unread.) In contrast with the religion in which Harris had been raised, theosophy subscribes to no creed or dogma. It therefore took him above ordinary laws, moral codes, and ethical systems – and gave him greater freedom. Moreover, his passionately held belief had a surprisingly invigorating effect on his life and work: theosophy aims its lessons precisely at self-development. It helped Harris to change his life and to become an abstract artist, as he did in 1934. Once he discovered this new orientation, which meant a profound change in his art practice, theosophy helped him stay committed to creating the abstract paintings – which he described as "purer creative work" – that he painted for the remainder of his life.

THE CANADIAN GROUP OF PAINTERS, AND INNOVATIONS OF THE 1930S

In the period of the existence of the Group of Seven, the members were transformed from pioneers to leaders of the Establishment. Bertram Brooker, one of the new talents of the day and one of the first to paint abstractly in Canada, felt that the Group's work became codified with time. It showed signs of hardening into a formula, Brooker said in 1928 – only eight years after their first show. By 1930 the original members were beginning to attain a degree of individual success, and group exhibitions were no longer necessary. In its last exhibition, in 1931, the Group showed, by invitation, the work of twenty-four other painters, including artists from Montreal, Ottawa, and Vancouver. The more talented of these contributors were then asked to join the Group of Seven in forming a new national organization, the Canadian Group of Painters. Among the new members were Brooker, Emily Carr, Prudence Heward, Yvonne McKague Housser, and Isabel McLaughlin. Harris showed his usual organizational skills in the endeavour: he wrote personal letters to many of the artists, inviting them to join, and he served as the organization's first president. The Canadian Group of Painters encouraged freer forms of expression. The influence of the Group of Seven, initially strong, gradually diminished.

A look at the work of the members of the new group, many of them inventive, provides an overview of Canadian painting from the dawn of the Depression in 1929 to the 1960s.

ABSTRACT ART

In his paintings of the 1920s, by demonstrating his interest in the spirit of the scene rather than the literal representation, Harris had started down the road to abstraction. Now he arrived at his destination.

Abstraction was discovered to celebrate the inner forces of spirit, mind, and nature in fresh visual language. The artist who is credited with the first abstract paintings is Wassily Kandinsky. From 1909 onward, Kandinsky divided his working into *improvisations, impressions,* and *compositions*. He saw these paintings as stages in the progression toward abstraction and as a way of conveying the spiritual

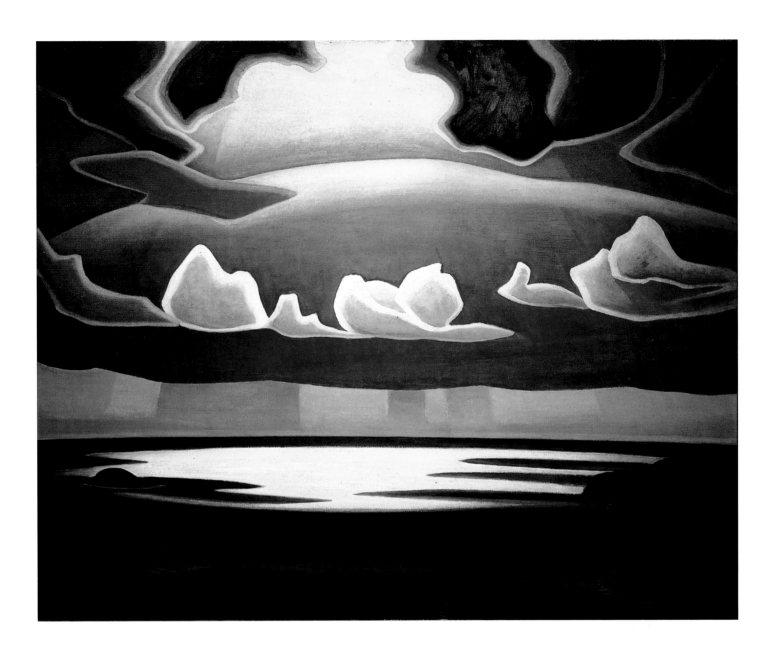

From the North Shore of Lake Superior c. 1923

Oil on canvas; 121.9 x 152.4 cm

value of art. He had become convinced that nature and representation presented an obstacle in this development. He therefore eliminated detail and depersonalized human character to allow an expression of his impressions of "inner nature" and impulse.

Abstraction, as used in Canada by artists like Harris, has qualities similar to those seen in Kandinsky's early work. Pioneers in abstraction took landscape and the figure as their images, filtering them through methods we still think of today as abstracting: summarizing, abbreviating, and stylizing. We should call the work of these breakthrough artists "approaches to abstraction," since most of them did not initially paint in a way that could be called "non objective."

Canadian artists painted abstractly for many reasons. Among them was the wish to grapple with the spiritual. They were painters who valued intuition over logic; they believed in universal truth.

Lawren Harris became an abstract artist in 1934 because he found such an art – which did not depict recognizable scenes or objects – full of great and enticing possibilities; and he found exciting the lack of predictable direction to his work.

This new realm of adventure was part of a general change in his life. In 1934, after years of being blocked as a painter, he left Trixie, his wife of twenty-four years, their three children, and his home, and married an old friend, painter and theosophist Bess Housser. He and Bess left Canada, settling in Hanover, New Hampshire, where Dartmouth College offered a happy cultural environment. Harris became the school's unofficial artist-in-residence. Here too he was near a good friend from his years in Berlin, his uncle William Kilbourne Stewart. It was at Dartmouth that Harris began to draw and paint again. In one sequence of drawings, he depicted a wooden door in a detailed, representational manner. In another, he focused on the grain of the wood. This second

drawing, of irregular curving lines, seems to be the starting point for a series of drawings – of wood-grain lines and random curves – that fused nature with the abstract. It was this series that led Harris to abstraction.

For Harris, what mattered about abstraction was that it could express several layers of meaning – the natural, the philosophical, and even the spiritual. He called abstraction a dance of the spirit. What mattered, writes religious studies scholar Dawn Ambler, was the act of painting as a spiritual practice and a disciplined experience of the Divine. As evidence, Ambler cites not only Harris's work and numerous writings, but also his refusal to title or date his abstract work.

His first works in New Hampshire explore ideas of balance and equilibrium. Harris used triangles and pyramids as symbols of human aspiration and likely also as references to his physical setting in the White Mountains of New Hampshire. He also used circles and spheres, perhaps as references to theosophy and the spirit. His colour range became pale and serene: beige, pale blue, and grey. His brushwork was calmer and more even than in his earlier (pre-1920) work. Paintings such as *Riven Earth I* (Composition 8) (opposite page) portray a healing view of the universe. Harris, who had spoken of creative life as a bridge, often painted bridges, abstracted, in his abstract work. A bridge in this painting resembles a wooden board: it splits the earth to connect imperfectly with paper steps climbing to a sky in which floats an aerial form. Beginning about 1937, perhaps to suggest realities that lie beyond appearances, he used transparent planes more often, and his general effects became more delicate. In the composition of some of these paintings he introduced an idea known as "dynamic symmetry," derived from Jay Hambidge's influential books that use geometry-based "recipes" for creating structure in a work.

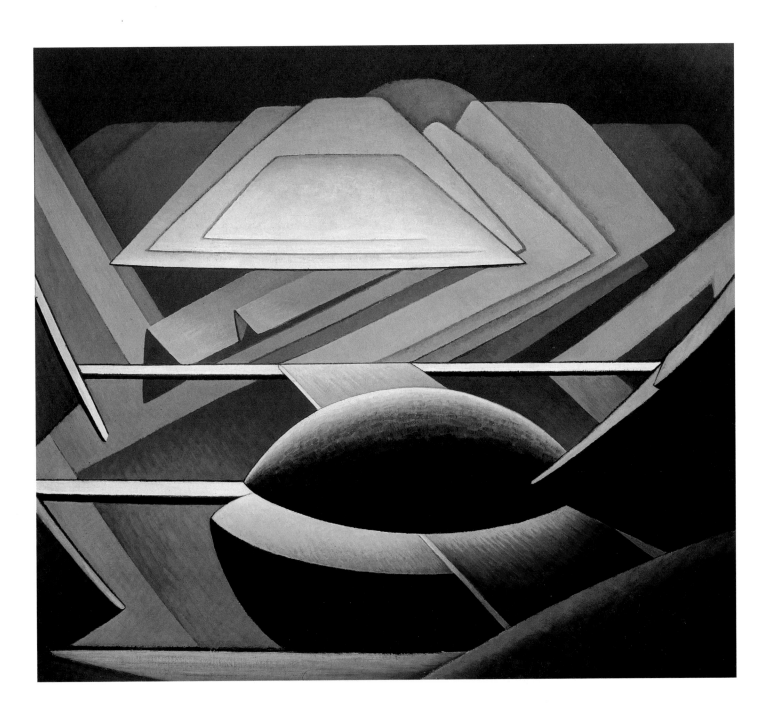

Riven Earth I (Composition 8) 1936

Oil on canvas; 80.0 x 92.0 cm

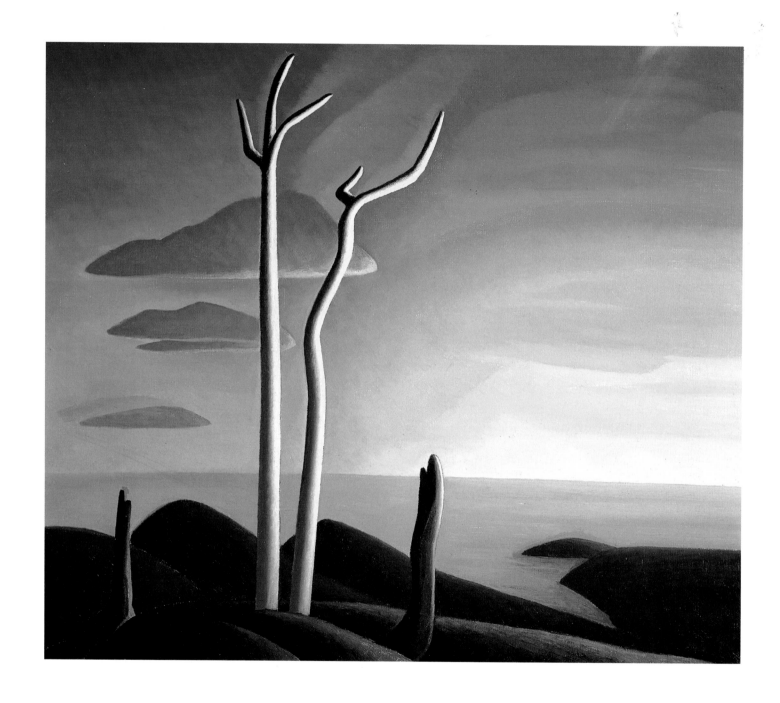

Lake Superior c. 1928

Oil on canvas; 86.1 x 102.2 cm

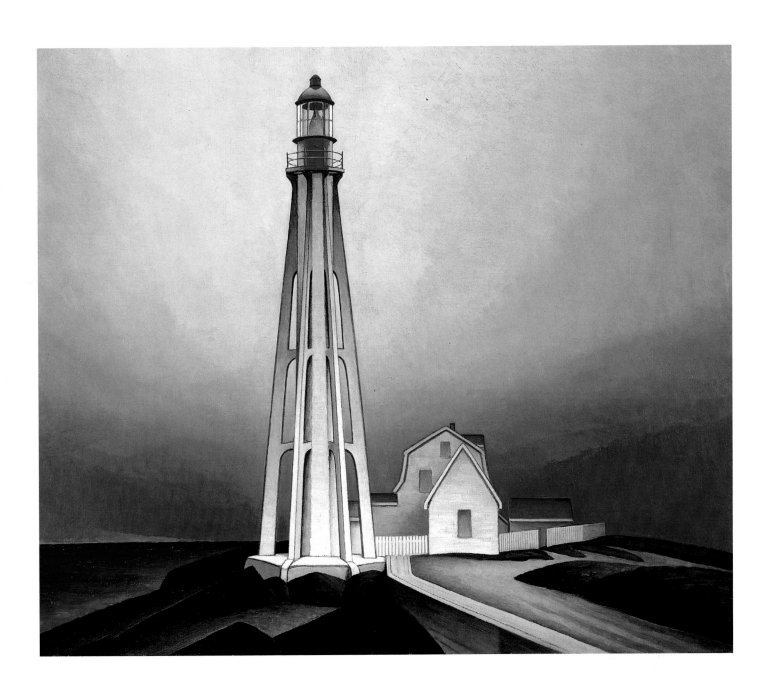

Lighthouse, Father Point 1930

Oil on canvas; 107.9 x 128.1 cm

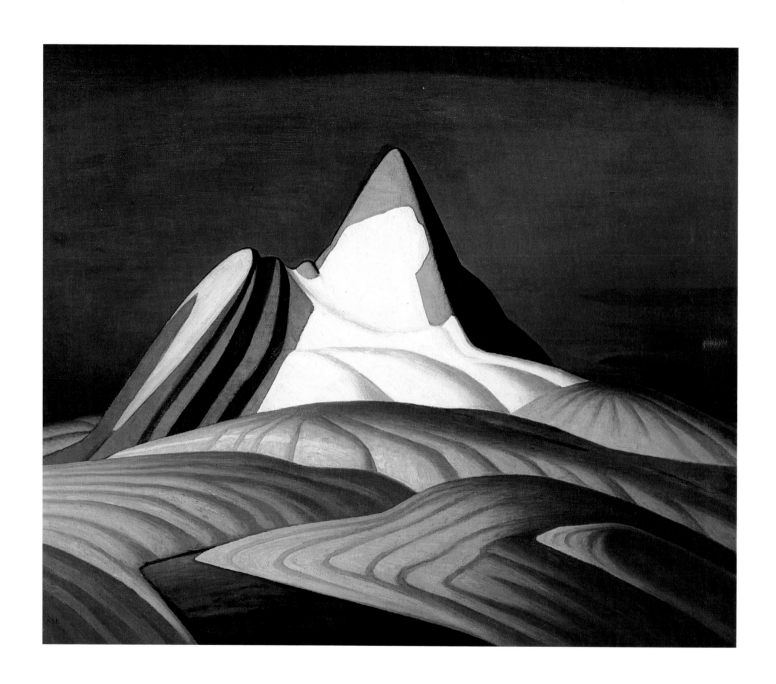

Isolation Peak c. 1930

Oil on canvas; 104.2 x 124.5 cm

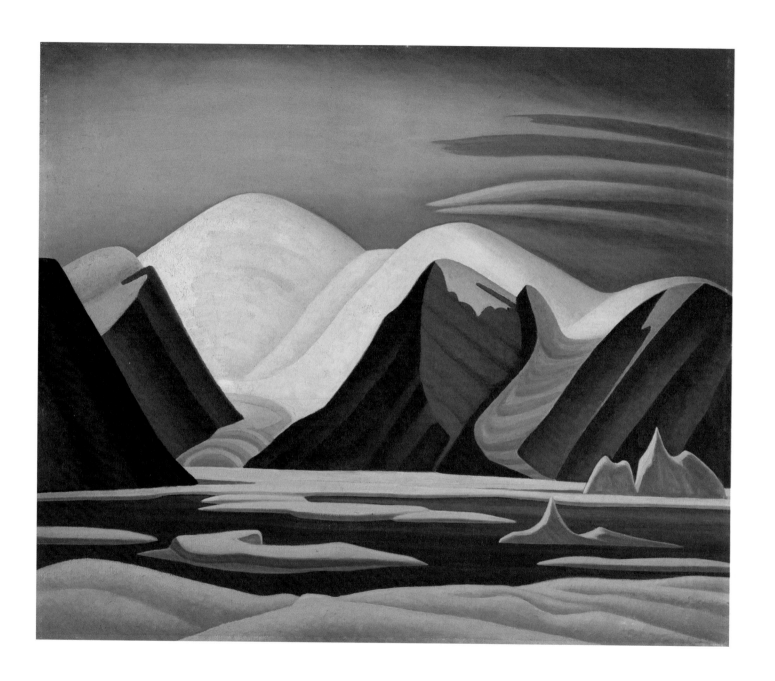

Greenland Mountains c. 1930

Oil on canvas; 107.4 x 128.4 cm

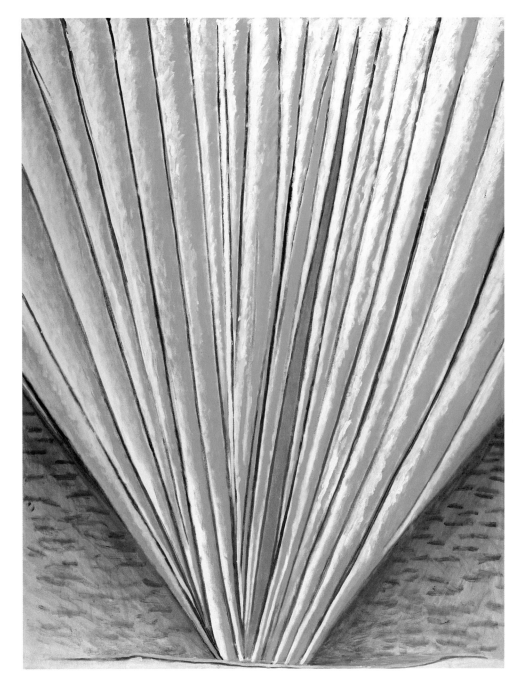

Untitled Abstraction "K" c. 1964

Oil on canvas; 161.6 x 125.3 cm

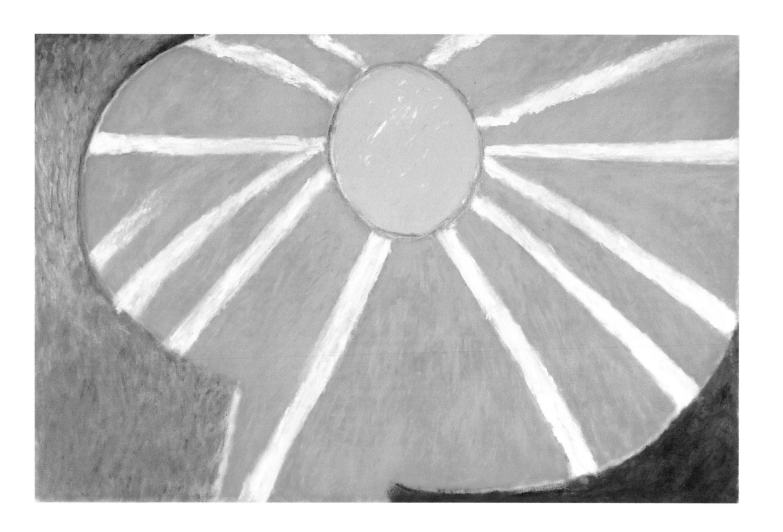

Untitled Abstraction "P" c. 1968

Oil on canvas; 106.9 x 165.4 cm

In what appears to have been a spontaneous move, in 1938 Lawren and Bess Harris decided to leave New Hampshire for Santa Fe, New Mexico. An old centre for artists involved in creative and religious speculation, the city, set in the Sangre de Christo mountains, provides an almost overwhelming setting and brilliant light. Harris found its creative community friendly and stimulating and soon helped to found a new art movement, the Transcendental Painting Group. The name was chosen to convey the idea of adopting new concepts to carry painting to imaginary realms.

But after less than two years, the Harrises moved on again. With the outbreak of the Second World War in 1939, Canada placed restrictions on funds moving outside the country. The Harrises, who depended on such monies, had to return to Canada. In 1940, they settled in Vancouver.

One of Canada's youngest major cities, Vancouver, with its mild climate and beautiful setting, offered Harris a new and sympathetic group of artists. Among them was the Scottish modernist painter Jock Macdonald, who had become an abstract artist in 1934 by applying Kandinsky's theory that colour harmonies could be constructed without reference to nature. Macdonald called such paintings "modalities." In time he became an important abstract artist in Toronto, and in 1953 was among the leaders of a new group of artists, Painters Eleven.

In Vancouver Harris quickly became a friend of Macdonald's and began to help foster an improved atmosphere for the arts. He assisted the Vancouver Art Gallery by serving as chairman of the exhibition committee from 1942 to 1956, and he founded the Federation of Canadian Artists. (Almost forgotten now, the federation came into being as a result of the

Kingston Conference, a national conference of the arts held in that Ontario city in 1941.) Along with the Labour Arts Guild founded in Vancouver in 1944, the Federation of Canadian Artists helped to integrate art and the lives of artists into other elements of society.

In Vancouver, Harris initially returned to his roots and in his abstractions used references to nature, although in a new and more spacious format. But surrealism soon influenced his work, probably the result of his association with both Macdonald and British artist and psychiatrist Grace Pailthorpe, who lectured in Vancouver on the subject. Surrealism was defined by its leading figure, French writer André Breton, as pure psychic automatism, by which an attempt is made to express the true functioning of thought. Harris began to develop drawings without preconceived ideas, bringing to his abstraction between 1945 and 1950 an undiminished vigour and willingness to experiment. The results in paintings such as *Nature Rhythms* (c. 1950) are even more exuberant forms and curving lines than those seen in his earlier works. In this canvas he assembled landscape forms, elements, and colours into a pattern that expressed his emotional and spiritual attachment to the land.

By the early 1950s, through trips to New York, he had become interested in abstract expressionism, a form of abstraction that developed there in the late 1940s. Abstract expressionism emphasizes the surface of the canvas, all-over treatment, accidental effects, and bold imagery. Harris found the new movement liberating. It led to greater freedom in his work, to larger paintings, to more open areas of bright colour, and to a more spontaneous handling of the figure and forms he had earlier found important. The idealistic impulse behind his work still played a role, but more often he was inspired to use free association.

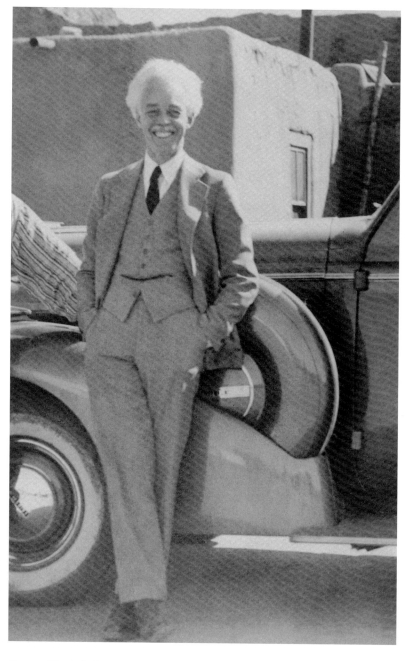

Lawren Harris in Santa Fe, New Mexico, c. 1939

Until his death in 1970 at the age of eighty-four, he continued to paint abstractly, although his designs became bolder and simpler and his brush stroke more highly textured, as in *Untitled Abstraction "K"* (p. 50). He was always highly motivated; he had self-discipline and deep-set work habits to carry him on. He called it "momentum." He painted every day in a steady pattern, even when, after major illness, he barely had the strength. In his last paintings, he was obsessed with light in the sense of the divine spirit and cosmic mysteries; in his canvases, colour is often applied to create a luminous effect, and the works have monumental compositions. The adventurous exuberance of these last works is inspirational.

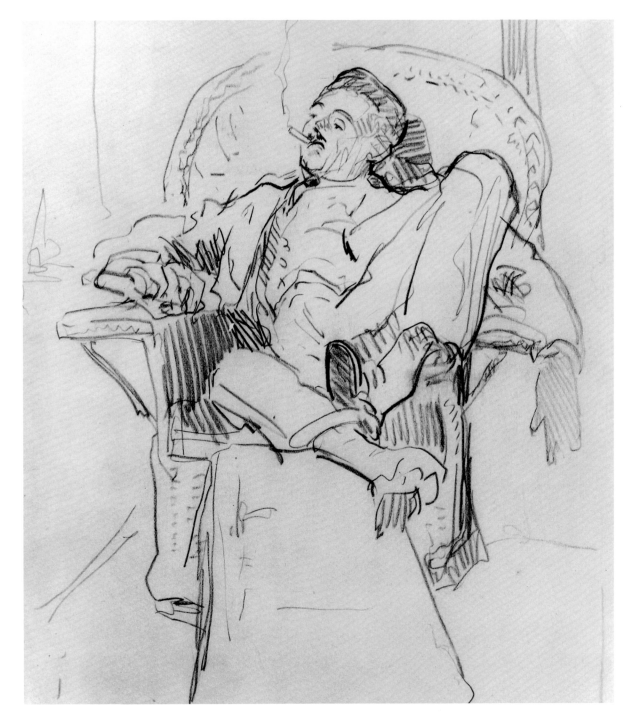

Lawren Harris, March 1920

Arthur Lismer 25.4 x 20.2 cm

Legacy

Lawren Harris was exceptional among major artists in at least three ways. He was born to wealth and never lacked for money. He was an intellectual who theorized about art and demonstrated his theories in his paintings. And he was a spiritual man for all his life, ultimately placing his spiritual ideas at the centre of his art.

Lawren Harris's long quest was for a style in which the demands of both spiritual life and art might be given their due. His legacy lies in his expression of the heart of Canada during a particular period and the breadth of effects he extracted from a medium that he defined broadly and inventively. He was versatile, developing from representation – particularly of land-scape – to abstraction. His reputation, strong in Canada and the subject of two retrospectives, in 1948 and 1963, is growing elsewhere. In 2000, a New York exhibition centre, the Americas Society, showcased his painting in a full-scale retrospective. This engaging exhibition opened the eyes of many international viewers to an artist whose paintings have a poignant romanticism and visionary radiance.

Chronology

This chronology has been compiled from many sources, notably the biography by Peter Larisey. I thank him for his suggestions.

J.M.

1885 October 23. Lawren Stewart Harris is born in Brantford, Ontario, at 150 Brant Avenue, the son of Thomas Morgan Harris and Anna Stewart. He is the first of two children His father is the secretary of The A. Harris, Sons & Co. Ltd., a manufacturer of farm machinery.

1887 January 14. Brother Howard is born.

1891 A. Harris, Sons & Co. amalgamates with Massey to form the Massey-Harris Company Limited.

1894 Spring–summer. Thomas Morgan Harris goes to New York to receive treatment for Brights disease. He dies in August.

Anna takes her boys to Europe, accompanied by her father, Reverend William Boyd Stewart, who lives in Toronto. After the trip, Anna, Lawren, and Howard return to Brantford. The family moves to Toronto, probably so that Anna can be nearer her father and mother, taking a house at 123 St. George Street.

1899 September. Charter pupil at St. Andrews College, a private school in Toronto's Rosedale. Fellow pupils include future Governor-General Vincent Massey (1887–1967) and Frederick B. Housser (1889–1936), the first writer to publish a book on the Group of Seven.

1903 Autumn. Begins to study in arts faculty at University College, University of Toronto. A mathematics professor, A.T. DeLury, seeing the character sketches he draws in class, convinces Anna that Lawren should study art in Europe. She agrees, provided that he go to Berlin, where he can be watched over by her brother, William Kilbourne Stewart, a teacher at Dartmouth College, New Hampshire, who is there studying German literature as a postgraduate student.

1904 Autumn. Travels to Berlin to begin training in studio classes with Franz Skarbina (1849-1910), Fritz von Wille (1860–1941), and Adolf Schlabitz (1854–1943). His enthusiasms in reading are William James and Ralph Waldo Emerson.

1906 Berlin. Sees *Ausstellung Deutscher Kunst aus der Zeit von 1775–1875* (exhibition of German Art).

1907 Summer. Goes on a walking tour with Schlabitz, during which he meets the German poet, philosopher, and painter Paul Thiem (1858–1922).

In Italy, meets Norman Duncan (1871–1916), Canadian expatriate author. In autumn, travels with Duncan to the Middle East to illustrate Duncan's travel articles, an account of a camel caravan from Jerusalem to Damascus, for *Harper's Monthly Magazine*.

1908 February. Returns to Canada.

Early autumn. First sketching trip, with Fergus Kyle, to Laurentians in Quebec. Charter member of the Arts and Letters Club of Toronto. Stimulated by dramatist Roy Mitchell, Harris begins to read Plato and Eastern texts.

1909 Spring. Sketching trip with J.W. Beatty (1869–1941) to Haliburton, Ontario.

Travels to northern Minnesota to paint canvases as illustrations for Norman Duncan's article, "A Man's Christian," in *Harper's Magazine*.

1910 Sets up studio on Yonge and Cumberland streets in Toronto over Giles's Grocery store (until 1914).

January 20. Marries Beatrice ("Trixie") Patricia Phillips in Toronto at the Anglican Church of the Redeemer. They live on Clarendon Avenue.

1911 March 31–April 29. Exhibits *Houses, Wellington Street* with the Ontario Society of Artists.

Elected a member of the Ontario Society of Artists.

November. Meets J.E.H. MacDonald and Tom Thomson at an exhibition of MacDonald's sketches at the Arts and Letters Club. Also meets Arthur Lismer, Franklin Carmichael, and Frank (later Franz) H. Johnston.

Sketches with MacDonald in Toronto.

1912 March 9–30. Shows *The Drive* with the Ontario Society of Artists.

Spring. Sketches with MacDonald in Mattawa, Temiskaming, Burks Falls, and Magnetawan.

Summer. Sketches in Georgian Bay, visiting Dr. James MacCallum at his cottage at Go-Home Bay.

Meets Frederick Varley who, having immigrated to Canada from Sheffield, England, joins the Arts and Letters Club.

Autumn. The National Gallery of Canada buys *The Drive*.

1913 January. Travels to Buffalo in the company of MacDonald to visit the Exhibition of Contemporary Scandinavian Art at the Albright Art Gallery.

February 15–March 15. International Exhibition of Modern Art (known as the Armory Show) is on view in New York City. The exhibition includes works by Cézanne, Gauguin, Matisse, and van Gogh, along with those by Canadians Ernest Lawson, E. Middleton Manigault, and David Milne, among others.

Spring. Harris purchases A.Y. Jackson's *The Edge of the Maple Wood* and, with MacDonald, invites Jackson to Toronto.

Autumn. Lends studio to Jackson to paint while waiting for Studio Building to open. Travels to Laurentians in the company of MacDonald.

1914 January. Opening of the Studio Building in Toronto at 25 Severn Street. Harris arranged for its construction, along with Dr. J.M. MacCallum, and has a studio in the building (until 1934).

August. First World War begins.

1915 Spring. Howard Harris joins the army.

Autumn. Sketches with MacDonald in Minden and Haliburton Highlands.

1916 April or early May. Visits Tom Thomson in Algonquin Park.

Spring. Enlists in the army.

June. Appointed lieutenant in the 10th Royal Grenadiers Regiment. Turned down for active duty, but spends two years as a gunnery officer, mostly at Camp Borden, near Barrie (until 1918).

1918 February 22. Howard Harris is killed in action while inspecting a German trench.

Suffers a nervous breakdown.

May. Receives a medical discharge from army. Travels to Algoma in the company of Dr. MacCallum.

August. Spends time at summer home "Woodend" at Allandale, Lake Simcoe.

Autumn. Sketches again in Algoma in the company of MacDonald, Johnston, and Dr. MacCallum. (He returns every year until 1924.)

November 8. The Exhibition of Paintings by Canadian Artists, organized by the National Gallery of Canada, tours the United States; two canvases by Harris are included.

1919 Moves to 63 Queen's Park.

Assists Hart House Theatre at the University of Toronto. Roy Mitchell, who has recently been appointed director, introduces him to theosophy.

April 26–May 19. Shows work at Art Museum of Toronto (today the Art Gallery of Ontario).

Spring. Second sketching trip to Algoma in the company of Jackson, Johnston, and MacDonald.

1920 March. With Carmichael, Jackson, Johnston, Lismer, MacDonald, and Varley, founds the Group of Seven.

May 7–27. Exhibits work in the first Group of Seven exhibition at the Art Gallery of Toronto.

1921 Spring. Sketches in Nova Scotia and Newfoundland.

May 5–29. Exhibits work in the second Group of Seven exhibition at the Art Gallery of Toronto.

Autumn. With Lismer and Jackson, travels to Algoma. With Jackson, travels to north shore of Lake Superior.

1922 May 5–29. Exhibits work in the third Group of Seven Exhibition at the Art Gallery of Toronto.

His book, *Contrasts, a Book of Verse*, is published.

1923 Travels for the first time to the Rocky Mountains. Travels to north shore of Lake Superior in the company of Jackson.

1924 March. Formally joins the Toronto Theosophical Society.

1925 January 9–February 2. Fourth Group of Seven exhibition held at the Art Gallery of Toronto.

July. Publishes "Revelation of Art in Canada" in *The Canadian Theosophist*.

1926	Shows at Sesquicentennial International Exposition of Philadelphia. Wins gold medal for his urban landscape, *Ontario Hill Town*. May 7–31. Fifth Group of Seven exhibition held at the Art Gallery of Toronto. August 26. Invited to join the Société Anonyme, a group founded in 1920 by American Katherine Dreier to foster the development of the acceptance of modern art. Other members include Kandinsky, Marcel Duchamp, and Man Ray. November 19–January 1. Travels to New York to view the International Exhibition of Modern Art Assembled by the Société Anonyme; Brooklyn Museum, New York.
1927	April 1–24. Sponsors the International Exhibition of Modern Art Assembled by the Société Anonyme at the Art Gallery of Toronto. Summer. Vacations at Temagami in Northern Ontario. Moves to home on Oriole Parkway. November 17. Meets and encourages Emily Carr (1871–1945).
1928	February 11–26. Sixth Group of Seven exhibition held at the Art Gallery of Toronto. Autumn. Travels with the Group of Seven on a sketching trip to the north shore of Lake Superior.
1929	Travels by car along the south shore of the St. Lawrence River.
1930	April 5–27. Seventh exhibition of the Group of Seven held at the Art Gallery of Toronto. Spring. Travels with his wife to Germany (Stuttgart and Munich) and France (Paris). In Paris, meets Marcel Duchamp. July 31. Leaves from Nova Scotia and, with Jackson, travels on the government supply ship *S.S. Beothic* to Greenland and the Canadian Arctic posts of Ellesmere Island, Devon Island, and Baffin Island. November 26–December 8. Shows Arctic sketches along with those of Jackson at the National Gallery of Canada.
1931	January. Wins Baltimore Museum of Art prize for *North Shore, Lake Superior*, in the first Baltimore Pan-American Exhibition of Contemporary Paintings. Builds a house in the Art Deco style at 2 Ava Crescent in Toronto, designed by Alexandra Biriukova (1893–1967). December 4–24. Eighth and final exhibition of the Group of Seven.

1931	Begins to form the Canadian Group of Painters.
1932	March 5–April 5. Shows work in Contemporary Canadian Artists exhibition, which he has helped organize at the Roerich Museum, New York.
1933	January–July 1934. Does no painting. Elected president of the Canadian Group of Painters. Resigns from Ontario Society of Artists. June 10–11. Attends first North American International-Intertheosophical Convention at Niagara Falls. June–September. Exhibits with the Canadian Group of Painters at the Heinz Ocean Pier, Atlantic City, New Jersey. November. Talks with Emily Carr, who is in Toronto on a visit. Exhibits with the Canadian Group of Painters at the Art Gallery of Toronto.
1934	June 13. Separates from his wife, Beatrice. Files for divorce in Reno, Nevada. August 29. Marries Bess Housser (1891–1969), probably in Nevada. Travels with Bess to Hanover, New Hampshire, to visit his uncle, William Kilbourne Stewart, at Dartmouth College. November 13. Resumes drawing and painting. Works as unofficial artist-in-residence at Dartmouth (until 1937). Mid-December. Paints first abstract work.
1935	Frequently travels by train to New York. June 7. Obtains visas for permanent residence in the United States.
1936	January. Exhibits work with the Canadian Group of Painters at the Art Gallery of Toronto. February 20–April 15. Exhibits work in the Retrospective Exhibition of Painting by Members of the Group of Seven 1919–1933, National Gallery of Canada.
1937	November 19–December 19. Exhibits first abstract work with the Canadian Group of Painters at the Art Gallery of Toronto.
1938	March 18. Arrives at Santa Fe, New Mexico. Decides to stay, and returns to New Hampshire to prepare the move. June. The Transcendental Painting Group is organized. (The Group is in existence until 1942.) October 1. Begins residence in Santa Fe (until 1940).

1939 Becomes president of the American Foundation for Transcendental Painting. Arranges (and exhibits in) a show of the Transcendental Painting Group at the Golden Gate International Exhibition in San Francisco.

August 1–September 15. Exhibits work with the Canadian Group of Painters in an Exhibition of Canadian Art at the New York World's Fair, an exhibition organized under the direction of the National Gallery of Canada.

1940 May 14–June 27. Exhibits with the Transcendental Painting Group at the Museum of Non-Objective Painting (later the Guggenheim Museum), New York.

Summer. Returns to Canada. Visits family and friends in Toronto.

Autumn. Moves to Vancouver to live. Meets Jock Macdonald.

1941 April 29–May 14. Subject of a one-person show at the Vancouver Art Gallery.

June 26–28. First National Conference of the Federation of Canadian Artists, held at Queen's University, Kingston, Ontario (the Kingston Conference).

July–August. Travels to the Rockies in the company of Jock and Barbara Macdonald.

Organizes a show of the Group of Seven at the Vancouver Art Gallery. Becomes a charter member of the Federation of Canadian Artists, founded in Toronto. Renews friendship with Emily Carr. Elected to the Council of the Vancouver Art Gallery Association.

1942 February. Exhibits with the Canadian Group of Painters at the Art Gallery of Toronto.

May 1–2. Attends the first annual meeting of the Federation of Canadian Artists at the Studio Building in Toronto and is elected regional convener for British Columbia.

June. Elected chairman of Exhibition Committee of Vancouver Art Gallery (until 1956).

Becomes a founding trustee of the Emily Carr Trust (until 1962).

1943 March 31. Gives a series of six talks on the Canadian Broadcasting Corporation radio; theme is "Art and Life."

Helps to form the Western Canadian Art Circuit.

1944 March. Elected national president of the Federation of Canadian Artists (until 1947).

Marches in the company of other artists on Parliament Hill to demand government support for the arts in Canada.

November. Lectures in Calgary, Regina, Saskatoon, and Winnipeg.

1945 November 23–December 16. Exhibits work with the Canadian Group of Painters at the Art Gallery of Toronto and the Art Association, Montreal.

1946 May 16. Receives honourary degree (LL.D.) from the University of British Columbia.

October 29–November 17. Subject of a one-person exhibition of abstract paintings in Victoria.

1947 Frequently travels to New York to see contemporary art. Exhibits work with the Canadian Group of Painters at the Art Gallery of Toronto and the Art Association, Montreal.

1948 October 15. Subject of a one-person retrospective, Lawren Harris: Paintings 1910–1948, at the Art Gallery of Toronto, the first time a living artist is so honoured by the gallery.

1950 Appointed to the board of trustees of the National Gallery of Canada (until 1961), the first practising artist so appointed.

1951 June. Receives honourary degree (LL.D.) from the University of Toronto.

Exhibits work with the Canadian Group of Painters at the Montreal Museum of Fine Arts.

1952 November. Exhibits work with the Canadian Group of Painters at the Art Gallery of Toronto.

1953 September. Receives honourary degree (LL.D.) from the University of Manitoba.

1954 March. Travels by car to Arizona.

Autumn. Publishes *Abstract Painting. A Disquisition*.

Writes *The Story of the Group of Seven* for a catalogue for a Group of Seven exhibition held at the Vancouver Art Gallery.

November, December. Exhibits work with the Canadian Group of Painters at the Art Gallery of Toronto.

1956 Travels with Bess by ship to Europe.

November 9–December 26. Exhibits work with the Canadian Group of Painters at the Art Gallery of Toronto.

1957 November–December. Exhibits work with the Canadian Group of Painters at the Montreal Museum of Fine Arts.

1958 Early April. Has open heart surgery for aneurism of the aorta.

 Appointed honourary vice-president of the Vancouver Art Gallery.

 September–October. Exhibits work with the Canadian Group of Painters at the Vancouver Art Gallery, the first exhibition of the group held west of Toronto; and attends opening in September.

1959 February–April. Travels by ship to Great Britain via the Panama Canal. Travels in Europe.

 November–December. Exhibits work with the Canadian Group of Painters at the Art Gallery of Toronto.

1960 November. Exhibits work with the Canadian Group of Painters at the Montreal Museum of Fine Arts.

1961 November. Exhibits work with the Canadian Group of Painters at the Vancouver Art Gallery.

1962 Awarded Canada Council medal for 1961.

 November. Exhibits work with the Canadian Group of Painters at the Art Gallery of Toronto.

1963 June 7–September 8. Retrospective exhibition at the National Gallery of Canada.

1964 Publishes *The Story of the Group of Seven* as a separate book.

1965 March–April. Exhibits work with the Canadian Group of Painters at the Art Gallery of Greater Victoria.

1966 April–May. Exhibits work with the Canadian Group of Painters at the Art Gallery of Hamilton.

 Autumn. Hospitalized for a month.

1967 Travels across Canada by train to see landscape.

 October–November. Exhibits work with the Canadian Group of Painters at the Montreal Museum of Fine Arts.

1969 *Lawren Harris* is published; edited by Bess Harris and R.G.P. Colgrove.

 March. Hospitalized.

 September. Bess dies.

1970 January 29. Dies in Vancouver at age eighty-four. He is survived by two sons, Lawren Phillips and Howard Kilbourne; one daughter, Mrs. Margaret Anne (Peggie) Knox; and five grandchildren and five great-grandchildren. Lawren Harris's ashes, and those of Bess, are buried on the grounds of the McMichael Canadian Art Collection, Kleinburg, Ontario.

 October. Posthumously named Companion of the Order of Canada.

Selected Sources and Further Reading

Ambler, Dawn. *Lawren Harris: A Theosophist Who Painted.* (Unpublished doctoral thesis), Department of Classics and Religious Studies, University of Ottawa, 2002.

Foss, Brian. "Synchronism" in Canada: Lawren Harris, Decorative Landscape, and Willard Huntington Wright, 1916–1917." *Journal of Canadian Art History* 20, 1 and 2 (1999), pp. 68–88.

Harris, Bess, and R.G.P. Colgrove. Lawren Harris (eds.). Toronto: Macmillan of Canada, 1969.

Harris, Lawren. *Abstract Painting: A Disquisition.* Toronto: Rous & Mann Press, 1954.

———. *The Story of the Group of Seven.* Toronto: Rous & Mann Press, 1964.

Hill, Charles C. *The Group of Seven: Art for a Nation.* Ottawa: National Gallery of Canada, 1995.

Housser, F.B. *A Canadian Art Movement: The Story of the Group of Seven.* Toronto: Macmillan, 1926.

Hunter, Andrew. *Lawren Stewart Harris: A Painter's Progress.* New York: The Americas Society, 2000.

Jackson, Christopher. *Lawren Harris: North by West: The Arctic and Rocky Mountain Paintings of Lawren Harris, 1924–1931.* Calgary: Glenbow Museum, 1991.

Larisey, Peter. *Light for a Cold Land: Lawren Harris's Work and Life – An Interpretation.* Toronto: Dundurn Press, 1993.

Mastin, Catharine M. (ed.). *The Group of Seven in Western Canada.* Toronto and Calgary: Key Porter and the Glenbow Museum, 2002.

Murray, Joan. *Canadian Art in the Twentieth Century.* Toronto: Dundurn Press, 1999.

———. *The Birth of the Modern: Post-Impressionism in Canadian Art, c. 1900–1920.* Oshawa: The Robert McLaughlin Gallery, 2000.

Murray, Joan, and Robert Fulford. *The Beginning of Vision: The Drawings of Lawren S. Harris.* Toronto and Vancouver: Douglas and McIntyre, 1982.

List of Works Reproduced

2

North Shore, Lake Superior, 1926.
Oil on canvas; 102.2 x 128.3 cm;
National Gallery of Canada, Ottawa.
Purchased 1930. 3708.

5

Red House and Yellow Sleigh, 1919.
Oil on board; 26.7 x 33.7 cm;
Art Gallery of Ontario, Toronto.
Gift from the Friends of Canadian
Art Fund, 1938. 2467.

6

Laurentian Landscape, 1913–1914.
Oil on canvas; 76.2 x 88.3 cm;
Private Collection.

8

Houses, Chestnut Street, 1919.
Oil on canvas; 81.7 x 97.2 cm; Robert
McLaughlin Gallery, Oshawa. Gift of
Joan F. Pelly, Edward D. Fraser, John
C. Fraser, Charles L. Fraser, 1985.

9

*Lawren Harris painting in the Studio
Building*, c. 1920.
National Gallery of Canada Library
and Archives, Ottawa. 33190.

10

Lawren Harris
Head and shoulders photo portrait of
the artist.
Photo: from lantern slide in
Audio/Visual Library, Art Gallery of
Ontario, Toronto. PH-31.

13

Interior with a Clothes Closet, 1906.
Watercolour on paper; 31.0 x 24.8 cm;
Private Collection.

14

Buildings on the River Spree, Berlin,
1907.
Watercolour mounted on cardboard;
59.7 x 45.6 cm; Collection of the Art
Gallery of Windsor. Gift of Mr. and
Mrs. E.D. Fraser, 1970. 71:33.

17

Houses, Wellington Street, 1910
Oil on canvas; 63.5 x 76.2 cm; Private
Collection. Photo: Christine Guest.

18

The Gas Works, 1911–1912.
Oil on canvas; 58.6 x 56.4 cm; Art
Gallery of Ontario, Toronto. Gift from
the McLean Foundation, 1959. 58/22.
Photo: Carlo Catenazzi/AGO.

20

The Drive, 1912.
Oil on canvas; 90.7 x 137.6 cm;
National Gallery of Canada, Ottawa.
Purchased 1912. 359.

23

Hurdy Gurdy, 1913.
Oil on canvas; 75.8 x 86.6 cm;
Art Gallery of Hamilton.
Gift of Roy G. Cole, 1992.

24

Snow II, 1915.
Oil on canvas; 120.3 x 127.3 cm;
National Gallery of Canada, Ottawa.
Purchased 1916. 1193.

25

Spruce and Snow, Northern Ontario,
1916.
Oil on canvas; 102.3 x 114.3 cm; Art
Gallery of Ontario, Toronto. Gift of
Roy G. Cole, Rosseau, Ontario, 1991.
91/419. Photo: Larry Ostrom/AGO.

26

*Autumn [Kempenfelt Bay, Lake
Simcoe]*, undated [c. 1916–1917].
Oil on canvas; 97.5 x 110.0 cm;
University College Art Collection,
University of Toronto Art Centre.
Photo: Thomas Moore.

27

Decorative Landscape, 1917.
Oil on canvas; 122.5 x 131.7 cm;
National Gallery of Canada, Ottawa.
Purchased 1992. 36813.

28

Snow, c. 1917.
Oil on canvas; 71.0 x 110.1 cm;
McMichael Canadian Art Collection,
Kleinburg. Gift of Mr. and Mrs. Keith
MacIver. 1966.16.88.

31
Luncheon at the Arts and Letters Club,
Toronto, c. 1920.
Gelatin silver print (vintage) on paper;
9.0 x 12.2 cm; Art Gallery of Ontario,
Toronto. Transferred from the E.P.
Taylor Research Library and Archives,
Art Gallery of Ontario, 1996. 96/59.

33
Beaver Swamp, Algoma, 1920.
Oil on canvas; 120.7 x 141.0 cm;
Art Gallery of Ontario, Toronto.
Gift of Ruth Massey Tovell, Toronto,
in memory of Harold Murchison
Tovell, 1953. 53/12.
Photo: Carlo Catenazzi/AGO.

34
Algoma Country, 1920–1921.
Oil on canvas; 102.9 x 127.5 cm; Art
Gallery of Ontario, Toronto. Gift from
the Fund of the T. Eaton Co. Ltd. for
Canadian Works of Art, 1948. 48/9.

35
Above Lake Superior, c. 1922.
Oil on canvas; 121.9 x 152.4 cm;
Art Gallery of Ontario, Toronto.
Gift from the Reuben and Kate
Leonard Canadian Fund, 1929. 1335.
Photo: Carlo Catenazzi/AGO.

36
Elevator Court, Halifax, 1921.
Oil on canvas; 96.5 x 112.1 cm;
Art Gallery of Ontario, Toronto. Gift
from the Albert H. Robson Memorial
Subscription Fund, 1941. 2570.
Photo: Carlo Catenazzi/AGO.

37
Red House, Winter, c. 1925.
Oil on canvas; 84.5 x 97.5 cm;
Hart House Permanent Collection,
University of Toronto. Gift of the
graduating class of 1932.
Photo: Thomas Moore.

38
Pic Island, c. 1924.
Oil on canvas; 123.3 x 153.9 cm;
McMichael Canadian Art
Collection, Kleinburg. Gift of
Col. R.S. McLaughlin. 1968.7.4.

39
Morning Light, Lake Superior, c. 1927.
Oil on canvas; 86.5 x 102.0 cm;
University of Guelph Collection at
Macdonald Stewart Art Centre. Gift of
Frieda Helen Fraser, in memory of her
friend Dr. Edith Bickerton Williams,
OVC '41, 1988. UG988.002.

41
Maligne Lake, Jasper Park, 1924.
Oil on canvas; 122.8 x 152.8 cm;
National Gallery of Canada, Ottawa.
Purchased 1928. 3541.

43
From the North Shore of Lake Superior,
c. 1923.
Oil on canvas; 121.9 x 152.4 cm;
Museum London. Gift of H.S.
Southam, Esq., Ottawa, 1940.
Photo: William Kuryluk.

45
Riven Earth I (Composition 8), 1936.
Oil on canvas; 80.0 x 92.0 cm; Robert
McLaughlin Gallery, Oshawa. Gift of
Isabel McLaughlin, 1987. 87HL35.

46
Lake Superior, c. 1928.
Oil on canvas; 86.1 x 102.2 cm;
National Gallery of Canada, Ottawa.
Vincent Massey Bequest, 1968. 15477.

47
Lighthouse, Father Point, 1930.
Oil on canvas; 107.9 x 128.1 cm;
National Gallery of Canada, Ottawa.
Gift of the artist, Vancouver, 1960.
5011.

48
Isolation Peak, c. 1930.
Oil on canvas; 104.2 x 124.5 cm;
Hart House Permanent Collection,
University of Toronto. Purchased with
income from the Harold and Murray
Wrong Memorial Fund, 1946. 46.1.
Photo: Thomas Moore.

49
Greenland Mountains, c. 1930.
Oil on canvas; 107.4 x 128.4 cm;
National Gallery of Canada, Ottawa.
Purchased 1936. 4279.

50
Untitled Abstraction "K," c. 1964.
Oil on canvas; 161.6 x 125.3 cm; Art
Gallery of Ontario, Toronto. Gift of
Elizabeth Anne Harris, Ottawa, 1995.
95/123. Photo: Carlo Catenazzi/AGO.

51
Untitled Abstraction "P," c. 1968.
Oil on canvas; 106.9 x 165.4 cm; Art
Gallery of Ontario, Toronto. Gift of
the Family of Lawren S. Harris, 1994.
94/826. Photo: Carlo Catenazzi/AGO.

53
Lawren Harris in Sante Fe, New Mexico,
c. 1939.
Photo: Courtesy Art Gallery of
Ontario, Toronto.

54
Arthur Lismer, *Lawren Harris,* March,
1920.
Charcoal on paper; 25.4 x 20.2 cm; Art
Gallery of Ontario, Toronto. Gift of
Mrs. R.M. Tovell, 1953, transferred
from the Edward P. Taylor Reference
Library, September, 1983. 83/265.

Index

Page numbers of illustrations are shown in **boldface** type.